(Opposite page) Hindmarch. Client: Holt Renfrew; CD: Sandy Kim; Stylist: Jay Barnett. 2016. Photographer: Colin Faulkner

DESIGN

Finn Nygaard: Curiosity and Calligraphy

HIS WORK DOES NOT HAVE ONE PARTICULAR STYLE:
IT IS MODERN, POST MODERN, DECORATIVE, AUSTERE.
HE IS GOVERNED BY HIS CONCEPT TO DETERMINE
THE APPROACH AND METHOD OF EXECUTION.
I AM IMPRESSED WITH THE RANGE OF HIS WORK.
Seymour Chwast, *Founder, Pushpin Studios*

AS AN ILLUSTRATOR, GRAPHIC ARTIST, AND
PHOTOGRAPHER, HE WORKS UNTRADITIONALLY
AND ARTISTICALLY. WHATEVER HE CONVEYS,
HE FINDS NEW DIMENSIONS. IT'S THE KIND THAT
MAKES A GREAT VISUAL ARTIST.
Evanthore Vestergaard, *Author, Composer, and Journalist, Forlaget Nordkraft*

SOFT SPOKEN AND MODEST, FINN EXEMPLIFIES THE
DANISH TRADITION OF HUMILITY, ALLOWING HIS
WORK TO SPEAK FOR HIM. IT IS NO SURPRISE THAT
HE IS RESPECTED THROUGHOUT THE WORLD AS
A GIANT OF DANISH AND INTERNATIONAL DESIGN.
Mervyn Kurlansky, *Designer, Mervyn Kurlansky Design*

FINN NYGAARD WITH FRIENDS
DET DANSKE KUNSTINDUSTRIMUSEUM
9. DECEMBER 2005 - 5. FEBRUAR 2006
BREDGADE 68 · DK KØBENHAVN K

(Page 9) Title: Save the Human Right. Client: Plakatjournal (German magazine)
(Above) Poster Exhibition. Title: Finn Nygarrd with Friends - Designmuseum Denmark (2005); 50-50 - Finn Nygaard: 50 Years, 50 Friends. Client: Designmuseum Denmark

Introduction by **Christian Brorsen** *Producer at Storyville Records*

Jazz is one of the ultimate expressions of creativity. At its best, it gives free reign to a form of ingenuity based on masterly technique, a sense of humor, attentiveness, and the courage to bring spontaneous ideas to fruition. The same can be said of Finn Nygaard. His virtuosity as a graphic artist has equipped him with a practically unlimited visual repertoire and technique that, among many other things, enables him to capture the essence of jazz music and create a wonderful harmonic symbiosis of audio and visual art.

(Page 12-15) Color Setting and Identity. Title: Airplane. Client: Danish Air Transport (DAT)

FINN NYGAARD IS ANOTHER GREAT DANE
WHO IS BOTH A DESIGNER AND FINE ARTIST THAT
CONTINUES TO DELIGHT VIEWERS
WITH HIS ENDLESS CREATIVE VIRTUOSITY.

B. Martin Pedersen, *Designer*

Tribute to Charlie Parker · 1920 - 1955

AARHUS
JAZZ
FESTIVAL
11-18 JULY 2020
JAZZFEST.DK

Title: Tribute to Charlie Parker, Aarhus Jazz Festival 2020. Client: Aarhus Jazz Festival, Denmark

14

Title: Tribute to Duke Ellington, Aarhus Jazz Festival 1989. Client: Aarhus Jazz Festival, Denmark

What is it about design that you are most passionate about?
The process, the challenge, and the communication. Also playing with colors, forms, and composition, as well as exploring, improving, and facing new challenges that lie around the corner.

What inspires or motivates you in your career?
I have always met new projects with eagerness and curiosity. All projects I have been involved with are good projects. But I have "marched." Since childhood I have been drawing (practicing) every single day. I can see today that my skills and my approach to new challenges have become better and better; also, I work in a more strong, free, and simple way. Curiosity, play, music ... the desire to touch the material, the paper, the ink ...

You've worked in many different design fields such as posters, corporate identity, color consulting, and illustrations. Which field is your favorite and why?
As is the case for most graphic designers, it all begins with the urge to draw, to explore techniques, etc. Composition and playing with colors are inevitably added to the process. The poster has, for me, always been the media and platform that unites it all. On this piece of paper that "forms" the poster, I can unite all disciplines and methods — drawing, calligraphy, typography, composition — and I can play until it gets "serious." And then play on. Add to it and reduce; simplify. All I gain here is transferred into my work with corporate identity, color consulting, illustrations ... everything.

Which project/piece(s) is your favorite and why?
It is difficult to talk about a special project. I work and play with design all the time. I am happy to have the chance to try many different disciplines. One day I work on a stamp, the next day a poster, and the third day with airplane color settings. Ideas are born and grow during these various processes. During the autumn of 2011, I was often provoked by debates about racism. As for most of us, presumably, the question "Where (and what) do we come from?" has "haunted" me for as long as I can remember. Reading articles about "the missing link" and the skulls of *Homo erectus* found in Africa and Asia added to that curiosity. According to my ideas about evolution, I really never understood why there is so much disagreement among people since we descend from the same "family." Bearing that in mind, we should treat each other like sisters and brothers and with respect, no matter if we are white, black, yellow, or blue! This was the basic idea and platform for creating the series of posters "We are All Equal." Starting with three individual and very different characters — Mao Zedong, Charlie Rivel, and Jimi Hendrix — I thought I had a nice little series of three posters. However, the process kind of caught me; I just could not stop with three. So many personalities have meant a lot to me during my life — both in a positive and a negative way.

With the skull as the repeated graphical element, I continued working with the series; within the next six months I came to count fifty-six posters, all 150 x 100 cm. Xavier Bermudez (director of the IPBM International Poster Biennial of Mexico) came to stay at my home for a couple of days. Xavier was very enthusiastic about the poster series and encouraged and invited me to prepare an exhibition for the next Mexico biennial (12th IPBM). Xavier's encouragement and enthusiasm "forced" me to grow the series. After another year, my aim was fulfilled; I had created ninety-nine posters with ninety-nine personalities. My first exhibition in Denmark was in an old city hall. My exhibition abroad showed the posters in the newly opened gallery of the University of Maristara in Querétaro, Mexico. There were also shows later in La Paz, Bolivia and Istanbul, Turkey.

Also, the Imam Ali Museum in Tehran, Iran invited me in May 2014. The total series of ninety-nine posters in their original size found its way into the Danish Poster Museum, and in 2016 all the posters were presented full size in the outdoor area of our local university here on the island where I live. It was great to see all of them outside, and they "survived" two months in our windy weather conditions. "We are All Equal" has become a traveling exhibition, which was actually not my intention in the beginning. The posters open doors and work for me; posters really belong to my heart.

You use many different methods and mediums in your work, such as ink painting. What drove you to learn about /use different mediums, and do you have a favorite?
Throughout the years I have travelled all over the world. The inspiration gained from these trips is clearly expressed in my posters and my INK works. Working with calligraphy is the elementary platform for experimenting and playing with light, shadow, the paper, the brush, and the ink. The ink is a fascinating "liquid." It has an immense impact. It expresses ease, elegance, and brutality when it hits the paper. The ink also strongly links the present with the past, thus calling for deep respect. The relationship between the posters and the ink is clearly reflected.

Music plays another essential role, from jazz to shakuhachi ... listening, feeling ... seeing ... feeling ... all senses linked together — a visual voice!

What is the most difficult challenge you've had to overcome in your career?
Doing design and corporate identity programs and color consultings for the Öresundstrain and Danish Air Transport. The Öresundstrain unites the Danish-Swedish region of Öresund, crossing two bridges and featuring an elegant color-setting, while the Danish Air Transport's planes take off with a spectacular palette of colors. I was awarded the Danish Design Prize for my part of the Öresundstrain project.

What are the benefits of having your own studio? Freedom.

You have had many exhibitions during your career. Which one has been the most memorable and why?
IdcN – International Design Center Nagoya in Japan. Because it was in Japan and because Japanese aesthetics appeals so much to me. They're actually quite similar to Nordic aesthetics. The exhibition, the setup, the days in Japan, the cooperation with the IdcN staff ... all was perfect.

You have also hosted many workshops and lectures during your career. Which workshop/lecture is the most memorable and why?
I had an exhibition and workshop in Tehran, Iran. The first day was difficult. The students were a little reluctant, a little shy ... maybe also a little afraid? Not because of me, but due to the fact that the room was monitored by "dark men" (morality police).

Soon, however, the students loosened up, and we had some very nice days together, working, evaluating, laughing ... All the students were very friendly, eager to learn and soak up all my advice, and hear about my experiences. Those were great days — and it was very nice to be together with the people that had arranged it all.

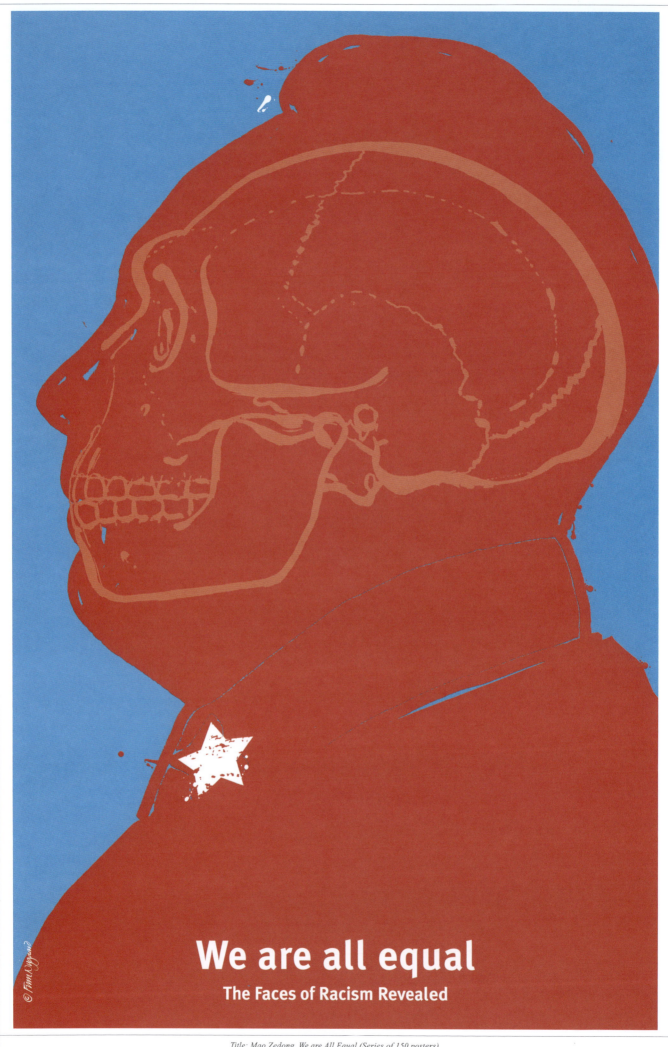

We are all equal

The Faces of Racism Revealed

Title: Mao Zedong, We are All Equal (Series of 150 posters)

Poster Exhibition. Title: Finn Nygaard - We are All Equal (Series of 150 posters). Place: Danish Poster Museum - Aarhus, Denmark

What do you hope to achieve in hosting workshops and lectures?
It is extremely important that we strive to educate design students to be unique and the absolute best. We must maintain and refine the artistic vein. Only by doing that can we preserve a unique and professional future for the creative professions.

The word and title design/designer is so abused; today anyone with a laptop and a few programs like InDesign and Photoshop claims to be a graphic designer. But there is a very long and complex way from being a happy jerk with the latest ironmongery to becoming a professional graphic designer, or any designer.

As for the lectures and workshops abroad, it is also important for me to say that it gives me great pleasure working together with other graphic designers from all over the world. It really inspires and urges me to go on doing what I am doing. And I can only urge design students to reach for as many international relationships, contacts, and activities as possible. It puts your life and the things you do into perspective.

My title of a workshop is often "Poster Composition - Jazz Improvisation." The purpose is to develop and strengthen the students' graphic design skills and competence working with composition.

The aim is to create and experiment with not just one but several/many compositions. Sense the size of the poster and work with it; see what happens when you add colored fragments to the paper. Make a composition that feels right, that convinces you that you are on the right path.

This discipline is tested and has proven successful; so successful that some students choose to focus working with this phase throughout the workshop! This workshop is not about the result. Commit yourself to the process, not the goal.

Improvisation is a broad term referring to the process of devising an atypical method to solving a problem due to lack of time or resources. In a technical context, this can mean adapting a device for some use other than that which it was designed for or building a device from unusual components in an ad-hoc fashion. Improvisation as a context of performing arts is a very spontaneous performance without specific preparation. The skills of improvisation can apply to many different faculties across all artistic, scientific, physical, cognitive, academic, and non-academic disciplines.

For me, it is very interesting to work with students all over the world, to build up the happiness of making a composition and feel happiness with the process.

I have been taking lots of photos of the students' fantastic results. And I hope in the future I can host many workshops with "Poster Composition - Jazz Improvisation."

*What upcoming exhibitions/workshops are you
most excited for and why?*
I just finished an exhibition, "JAZZ on Paper," in a museum in Denmark. These days, I'm preparing my next exhibition, "JAZZ and INK."

Who were some of your greatest past influences?
El Lissitzky and Kazimir Malevich. In 2019, I had the honor to be in the jury for 100 Years of UNOVIS for Vitebsk Art School that was founded and led by Kazimir Malevich in 1919. Bauhaus, Katsushika Hokusai, A. M. Cassandre, and Henri de Toulouse-Lautrec are other great influencers.

*Who is or was your greatest mentor? Who among your
contemporaries today do you most admire?*
I had three posters in my room as a child drawn by French artist Henri de Toulouse-Lautrec, Danish poster artist Ib Antoni, and Polish master Waldemar Swierzy (who later became my very good friend). I am influenced by culture, art, people, places, and nature from all over the world. Eastern culture, however, holds a special place in my heart. Later, I was very inspired by Alan Fletcher, Christian Dotremont, and Push Pin Studios in New York.

*Who has been some of your favorite people
or clients you have worked with?*
There are no bad clients, only bad graphic designers.

*Given all you have accomplished, what is your
greatest professional achievement?*
Still being a graphic designer with my own studio. It was founded in 1979. I'm still here, and in some ways, it's still just beginning.

*Being from Denmark, how do you feel your
culture has influenced your work?*
A good design tradition, using designers to help solve projects and challenges, and letting the designers be part of the project in an early stage. Also, a good educational system, and another good tradition of keeping things simple and functional and not adding unnecessary items.

What interests do you have outside of your work?
My "inside" work is with me "outside" my work. I cannot separate them. And I'm always curious about art, anthropology, the universe, history, and the environment. Travelling around the world with my Lieca camera is also a precious activity.

How do those interests influence your work and career?
All the time ... everything ... they melt together with my work.

What professional goals do you still have for yourself?
Create some books: a book about my workshop "Poster Composition - Jazz Improvisation," a book about JAZZ posters and INK, a book with a lot of graphics and with portraits taken with my Leica, one new poster ... one new INK ...

What advice would you have for students starting out today?
Artistry, passion, and a good pencil! The inspiration must come from yourself. Open your eyes and see what happens around you; be curious, be careful, and look after the child in yourself. Everything happens so fast; that is really challenging for a young designer.

Finn Nygaard finnnygaard.dk
See his Graphis Master Portfolio on graphis.com.

WE MUST MAINTAIN AND REFINE THE ARTISTIC VEIN. ONLY BY DOING THAT CAN WE PRESERVE A UNIQUE AND PROFESSIONAL FUTURE FOR THE CREATIVE PROFESSIONS. **Finn Nygaard,** *Designer, Finn Nygaard Design*

Mexico City

Save the Water

Title: Save the Water - Mexico City. Client: Bienal Internacional del Cartel en México (BICM)

Atsushi Ishiguro, OUWN: Designing is Like Cooking

ATSUSHI ISHIGURO'S PACKAGE DESIGN PERFECTLY
FRAMES OUR SELECT JAPANESE TEAS.
IT COMBININES THREE LANGUAGES AND A UNIQUE
DESIGN THAT IS BOTH FRESH AND TRADITIONAL.
WE LOVE WORKING WITH HIS TEAM.
Michiko Ono, *MATSU KAZE Tea*

ONE OF THE MOST ATTRACTIVE POINTS OF OUWN
IS THAT THEY CAN HANDLE A WIDE RANGE OF
DESIGN TONES DEPENDING ON THE PRODUCT. THEY
ALWAYS FOLLOW OUR FUNDAMENTAL REQUESTS,
YET ADD VARIOUS IDEA DIRECTIONS INTO IT.
Sayaka Nishinami, *KINTO Japan*

HIS WORK IS PRECISE, YET IT LEAVES ROOM TO
IGNITE PEOPLE'S IMAGINATIONS. I BELIEVE THIS
IS WHAT ATTRACTS PEOPLE TO HIS DESIGNS.

WORKING WITH MR. ISHIGURO ALWAYS INSPIRES
ME; HE UNDERSTANDS MY INTENTIONS BETTER
THAN MYSELF, WHICH MAKES ME REALIZE MY
OWN IDEAS MORE CLEARLY.
Ryutaro Miyoshi, *Sake Miyoshi*

(Page 23, Above) Sake Miyoshi

Introduction by **Hisayukki Niitsuma** *THE SUIT COMPANY*

In conducting each promotion, Mr. Ishiguro works on the main visual, store production, our homepage design, and more. We have received great support. He is disciplined, supervising and designing everything from planning to shooting at the end. His designs are rich in variety, such as converting one material into different sizes, combining them to make it three-dimensional, and adding a little color to change the overall atmosphere; we never get tired of receiving suggestions. He is a great designer. Also, his personality is good and he is always helping me in my work. He is currently working on a design for future promotions.

Maturity A to Z Typography Box

I BELIEVE THAT AS LONG AS YOU DON'T MAKE COMPROMISES, EVEN WHEN YOU HAVE TO MAKE UNEXPECTED CHANGES TO YOUR WORK, THERE IS ALWAYS A PATH THAT WILL PUSH YOU TOWARDS WONDERFUL CREATIVITY.

Atsushi Ishiguro, *Creative Director and Founder, OUWN*

What inspired or motivated you into your career?
The direct motivation for my choice of career was the environment and the appreciation I had for it as a child. I would draw for the love of it and people would praise my work, plus my family loved art in general. They made the little things I did feel big.

What is your work philosophy?
I believe that as long as you don't make compromises, even when you have to make unexpected changes to your work, there is always a path that will push you towards wonderful creativity.

What is it about design that you are most passionate about?
I'm passionate about all of it honestly, but if I had to pick just one aspect it would be graphic design. Within that area, I'm particularly passionate about things that people can touch with their hands.

What is your favorite type of assignment to work on?
I like projects where I can take a product or subject and reorganize it and present it in a stronger manner. I would maybe say that product advertising, branding, and other such "problem solving-style" tasks are my specialty.

Who is or was your greatest mentor?
The Japanese art director, Kenjiro Sano. His works have a distinctively simple, clear, and powerful style. He was also my mentor before OUWN.

What is the most difficult challenge you've had to overcome?
Presentations. I've developed certain skills in graphic design, like expressiveness and the ability to incorporate ideas, but I have doubts over how well I can communicate these skills. I think this can partially be credited to the fact that I'm still growing as a designer, but presentations are just as important as graphic design in this field, so I'm trying to make progress on that front.

Who were some of your greatest past influences?
The artist René Magritte is a huge source of inspiration for me, from a design perspective. Even though the tools he used were different to my own, the ideas and the wonder he produced, combining things with very different qualities, and changing perspectives all inspire me and are a constant source of motivation.

Who among your contemporaries today do you most admire?
René Redzepi, the chef-owner of Noma. I take a lot of inspiration from cooking, and I actually think cooking and design are quite closely related. We even extol the virtues of running your office like a restaurant.

The quality of a design is like the flavor of a meal. The layout of a page is like the use of color and space on the plate. Meetings are like serving customers; they both have the same ideal output of surprising and pleasing the client. So in that sense, I think he's an incredible designer.

What would be your dream assignment?
In the past, I've had the opportunity to work with two of my favorite design offices, Anagrama in Mexico and Deutsche & Japaner in Germany. But I would very much like to do so again. Those times were like a dream to me.

Can you tell us a little about OUWN and how you founded it?
OUWN was founded as two members and a programmer.
It was created to break free from the framework of graphic design and approach creativity from all kinds of different angles.

Was there a project that impacted your growth either as a company, or an individual?
Working on the Starbucks frappucino. Of course, we had to direct the photoshoot and handle the graphic work, but there was also event directing, illustrations, manufacturing, and more. So that helped develop my sense of balance between the graphic aspect of the business and the more diverse, multifaceted side.

Who have been some of your favorite people or clients you have worked with?
A client that I took a liking to? Well, there's a suit brand in Japan called THE SUIT COMPANY. They're currently trying to cut a new path in the industry by diversifying from suits and including more casual clothes in their lineup. Trying to break into a new market like that is a worthwhile endeavor. I found it interesting how it felt like we were both walking the same path, so I quite liked them.

What are the most important ingredients you require from a client to do successful work?
In order to create something great, I think what's most important is for them to really work together with us.

What is your greatest professional achievement?
Just being able to take on jobs, and hearing words of thanks and praise in return.

What part of your work do you find most demanding?
Being flexible, but also almost contradictorily firm when needed, while also being uncompromising in the pursuit of accuracy.

What professional goals do you still have for yourself?
I'd like to win some kind of award outside of Japan, even if it's just something small. I say that because I've been thinking a lot about what it means to be "first place" lately.

What are some things you wish you knew about the industry when you first started?
The first thing I'd like to learn in any industry is what the newest, most cutting edge things are.

What advice would you have for students starting out today?
I'd tell them that before you focus on making what you enjoy and such, try experimenting with emphasizing speed as you create different designs. See how quickly you can increase your accuracy, how quickly you can create a number of designs, things like that.

What interests do you have outside of your work? Cooking.

What do you value most?
Joy and wonder. I create things that try to inspire those emotions.

Where do you seek inspiration?
In meals at restaurants.

How do you define success?
Receiving acclaim for my work, and having both myself and my client walk away delighted.

Where do you see yourself in the future?
Enjoying a nice meal with someone important to me I think.

OUWN jp.ouwn.jp

THE SUIT COMPANY *Non Iron Visual Design*

Nue Inc. Envelope Design

LUMINE "Life is Journey"

#REDonNOSE #REDonNOSE

#REDonNOSE

WildAid REDonNOSE Visual Design

Waterfront Package Design

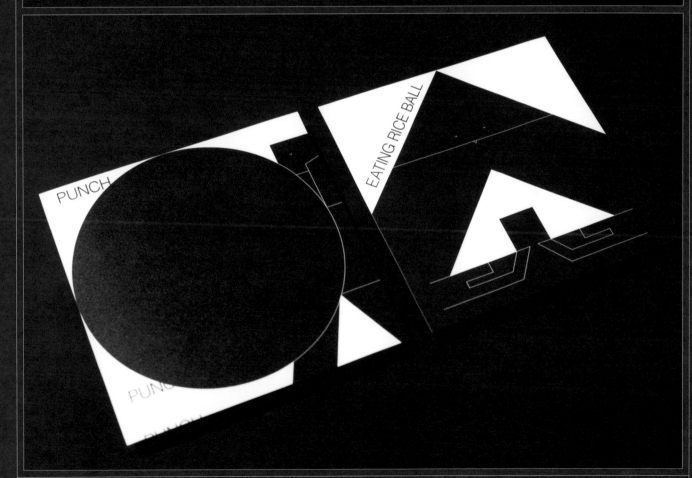

Block & Black Small Package Design & DM

RUN & STOP

PRODUCED BY PEOPLE AND THOUGHT

Block & Black Package Design

Give Up Plastic Poster

CHANCE

LOFT WORK
YEAR END
PARTY
2019

2019.12.06 Fri
@SCRAMBLE HALL
18:00-21:00
in SHIBUYA QWS
open 17:30-

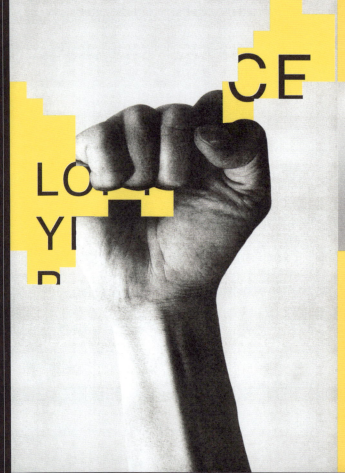

CE CHANCE

WORK
EAR END
PARTY
2019

2019.12.06 Fri
@SCRAMBLE HALL
18:00-21:00
in SHIBUYA QWS
open 17:30-

Loft Work Year End Party Visual Design

DOING SHOOTS FOR NETWORK TV IS NEVER EASY, BUT FBC ALWAYS HAS A SOLID GAME PLAN AND LEAVES ENOUGH ROOM TO FIND UNEXPECTED PIECES OF MAGIC. THEY TAKE THE RAW IMAGERY AND COME BACK WITH SOMETHING EXCELLENT.

Mathieu Young, *Photographer*

WORKING FOR OVER A DECADE WITH FX AND FOX TV, I'VE WORKED ON SOME AMAZING PROJECTS. THEY'VE GIVEN ME THE CHANCE TO PUSH BOUNDARIES AND EXPAND THEIR IDEAS. I AM BLESSED TO WORK WITH CREATIVES LIKE THIS.

Frank Ockenfels, *Photographer*

I'VE WORKED WITH THE TEAM AT FBC FOR OVER A DECADE ON NUMEROUS SHOOTS. THE ENTIRE TEAM HAS ALWAYS BEEN GREAT AND PAUL SPECIFICALLY HAS BEEN AN AMAZING COLLABORATOR EVERY TIME WE HAVE WORKED TOGETHER.

Justin Stephens, *Photographer*

Deadly. Cold-blooded. Family.

Empire

FOX

Empire - "Coiled in Deception". Art Director: Moises Cisneros

Next Key Art. Chief Creative Director: Mitch Strausberg; Art Director: Lindsey Conway

Introduction by **Thomas Morissey** *Former Design SVP, FBC Design*

The Fox Entertainment Design Team is the in-house creative unit that concepts, designs, and produces key art for Fox Entertainment's prime-time schedule, plus diverse projects thrown their way. Their outstanding design over the last fifteen years has garnered many awards and established the look of the Fox Entertainment brand. In my eyes, they don't get enough credit for these achievements. Gifted with extraordinary talent, this small, tight-knit, and artistically diverse group is daring, bold, and unrelenting in their creative approach. Their typical workday is a myriad of high-priority projects and goals that shift hourly. Brainstorming a series launch, last-minute revisions of a project shipping yesterday, and the instant turnaround of an unexpected assignment: it's all handled. Despite the need to combine artistic goals with network objectives, they've created a body of work that is, at the very least, inspiring, and at the utmost, spectacular. As their co-worker, then creative director, then design SVP, I was witness to their evolution in vision and expertise, and participated in the journey from colleagues, to a team, to a family. Both personally and professionally, this talented group has influenced me even more than I may have influenced them.

Sleepy Hollow Key Art. SVP: Tom Morrissey; VP: Mitch Strausberg; AD: Paul Venaas; Finisher: Moises Cisneros; Photography: Mattieu Young

I LOVE THE WORK FX CREATES. THEIR WORK ALWAYS BREAKS THROUGH THE CLUTTER IN A CROWDED LANDSCAPE. THEY HAVE GREAT CONCEPTS WHICH ARE ALWAYS WELL-EXECUTED AND THEY'RE NOT AFRAID TO PUSH BOUNDARIES.

Lindsey Conway, *Art Director, FBC Design*

What inspired or motivated you into your career?
Moises Cisneros (M.C), Senior Digital Finisher/Art Director: There have been different times in my life that have gradually steered me into my career. Early on when I was like six years old, I was inspired by a pencil drawing one of my older cousins had created in art school. It was a drawing of a man's face, and it caught my attention and made a deep impression on me.
Paul Venaas (P.V), Senior Art Director: Music advertising.

Who among your contemporaries today do you most admire?
Phil Bates (P.B), Art Director: Mark Gill, the greatest boss I ever had at Miramax Films.
Lindsey Conway (L.C), Art Director: I love the work FX creates. Their work always breaks through the clutter in a crowded landscape. They have great concepts which are always well executed and they're not afraid to push boundaries.
Jason Schmidt (J.S), Senior Art Director: Banksy.
M.C: There are many, not only designers but also artists from many disciplines: illustrators, sculptors, 3D artist, concept artists, etc. One individual whose work I have admired for a long time is Syd Mead.
Mitch Strausberg (M.S), VP, Creative Director: Neil Kellerhouse, Paula Scher, Banksy, Alexander McQueen, and Kehinde Wiley, to name a few.
P.V: Banksy.

What part of your work do you find most demanding?
P.B: Fighting for the most creative work.
P.V: Work/life balance. Trying to be a successful father and artist.

Who is or was your greatest mentor?
P.B: George Blume, my first boss (Sr. AD) working in NYC.
L.C: Tom Morrissey gave me a chance when I wanted to make a career change from TV producer to graphic designer. He gave me a shot in his department with a role described explicitly as "not a design job." Despite this, Tom allowed me to contribute my own work in department presentations, providing constructive criticism as if I was one of the designers. Because of his feedback and encouragement, my work began to reflect those of my peers. As a mentor, Tom fostered a supportive and positive environment for me to become an art director.
J.S: My father.
M.C: I have two mentors, Tom Morrissey and Mitch Strausberg. They have both seen my development in the department, they both started as art directors and have been supportive and encouraging of my career.
M.S: This may sound cliché, but looking back over my career I would have to say that Tom O'Neal, my high school graphic art teacher, was my biggest mentor. He is the person who first introduced me to advertising and graphic design, and encouraged me to pursue the field.
P.V: Raygun/Chris Ashworth and Robert Hales.

Who were some of your greatest past influences?
J.S: Drew Struzan.
P.V: David Carson.

What is your proudest professional achievement?
J.S: Receiving a Graphis award.

What interests do you have outside of your work?
J.S: Photography and drumming.
P.V: My children and family.

What is your work philosophy?
P.V: Even when you're not feeling creative … just keep digging.

What has been your most memorable project?
P.V: *Terminator: The Sara Connor Chronicles.*

What is the most difficult challenge you've had to overcome?
P.V: Retaining a thick skin and positive attitude when others may not have the same design aesthetic.

Who have been some of your favorite people or clients you have worked with?
P.V: The photographers I've collaborated with … Frank Ockenfels, Justin Stephens, Matthieu Young, and many others.

What are the most important ingredients you require from someone to do successful work?
P.V: Knowing when to be flexible and when to be uncompromising.

What is the greatest satisfaction you get from your work?
P.V: Self-satisfaction. Creating work that I am proud of even if it doesn't get past the first round.

What advice would you have for students starting out today?
P.V: Integrity and hard work.

What do you value most?
P.V: My children and family.

Where do you seek inspiration?
P.V: There are so many resources available that weren't available ten years ago … like Pinterest …

FOX Broadcasting Company Design www.fox.com

EVEN WHEN YOU'RE NOT FEELING CREATIVE… JUST KEEP DIGGING.

Paul Venaas, *Senior Art Director, FBC Design*

24 Legacy Teaser. SVP: Tom Morrissey; VP: Mitch Strausberg; Agency: FBC Design

STEPHEN DORFF

The hero no one saw coming.

DEPUTY

▼ THU 1/2
FOX

Deputy - "The New Sheriff In Town". SVP Creative Advertising: Tom Morrissey; Chief Creative Director: Mitch Strausberg; Art Director: Jason Schmidt

TERMINATOR
THE SARAH CONNOR CHRONICLES

01.14.08
FOX

Terminator: The Sarah Connor Chronicles - "Hanging Girl." SVP: Michael Vamosy; VP: Tom Morrissey; AD: Paul Venaas; Finisher: Moises Cisneros; Photography: Jill Greenberg

Evil has a
new home

THE
EXORCIST
FOX FALL

The Exorcist Season 2 - "Demon Within". Art Director: Jason Schmidt

In the City of Angels,
he's not one.

LUCIFER

MONDAYS
SEPT 19 FOX

*Lucifer Season 2 Key Art. Art Director: Lindsey Jaffin Conway; Chief Marketing Officer: Angela Courtin; Retoucher: Moises Cisneros;
Senior Vice President, Design: Tom Morrissey; Vice President, Creative Design: Mitch Strausberg*

X Files Campaign. Art Directors: Lindsey Jaffin Conway, Moises Cisneros, Rob Biro, & Jason Schmidt; Chief Marketing Officer: Angela Courtin;
Retoucher: Sherry Spencer; Senior Vice President, Design: Tom Morrissey; Vice President, Creative Design: Mitch Strausberg

JOHN SLATTERY

Never create
what you can't control.

neXt

EVENT SERIES
FOX 2020

f @neXtOnFOX 🐦 @neXtOnFOX 📷 @neXtOnFOX
#neXt

The Birth of AI. AD: Moises Cisneros; Chief Creative Director: Mitch Strausberg; SVP, Creative Advertising: Tom Morrissey

A killer new series from the creators of
GLEE and **AMERICAN HORROR STORY**

SCREAM QUEENS

SEPT **FOX**

Pretty evil.

Oh. My. Gauze.

SCREAM QUEENS

TUESDAYS SEPT 20 FOX

Scream Queens Key Art - "Oh. My. Gause." SVP: Tom Morrissey; VP: Mitch Strausberg; Agency: Iconisus; Photography: Matthias Clamer

ADVERTISING

BVK HELPED US LAUNCH A NEW PRODUCT IN 2020, WHICH WE CALLED "THE YEAR OF THE PIVOT." THEIR CONCEPTS WERE BIG AND STRATEGIC, AND AS THE WORLD KEPT THROWING US CURVE BALLS, BVK STAYED FLEXIBLE AND SHARP DURING EXECUTION.

Jamie Schmelzer, *Senior Director of Strategic Growth, Johnsonville*

BVK LEVERAGED THE STRENGTH OF THEIR ENTIRE TEAM TO DEVELOP SOME AMAZING WAYS TO INCREASE AWARENESS FOR OUR BRAND. THEIR IDEAS WERE AWESOME AND THEY EXECUTED THEM TO PERFECTION!

Phil Sklar, *Co-Founder and CEO, National Bobblehead Hall of Fame and Museum*

I'M SO PROUD OF WHAT BVK HAS DONE FOR US! THEY'VE CAPTURED THE SPIRIT OF OUR GREAT STATE AND TRANSLATED THAT INTO COMPELLING STORIES, WHICH HAS TRANSLATED INTO MORE PEOPLE VISITING WYOMING EVERY YEAR.

THEIR TEAM IS PASSIONATE ABOUT THIS WORK, AND IT SHOWS. WE KNEW THEY WERE DEDICATED TO OUR ACCOUNT, BUT WHEN COVID-19 HIT, THEY SHOWED UP FOR US AND HAVE BEEN AN EXCELLENT PARTNER AS WE NAVIGATE THROUGH RECOVERY.

Diane Shober, *Executive Director, Wyoming Office of Tourism*

One will dominate.
The rest will submit.

National Endurance Barefoot Water Ski Championships • August 25-26, 2018 • Crandon, WI

footstock
FOOTSTOCK2018.COM

*DOMINATE. Group Creative Director: Matt Herrmann; Copy Director: Mike Holicek; Senior Vice President, Cause Marketing: Gary Mueller
Retoucher: Anthony Giacomino; Photographer: Lucian McAfee; Print Production Director: Rob Birdsall*

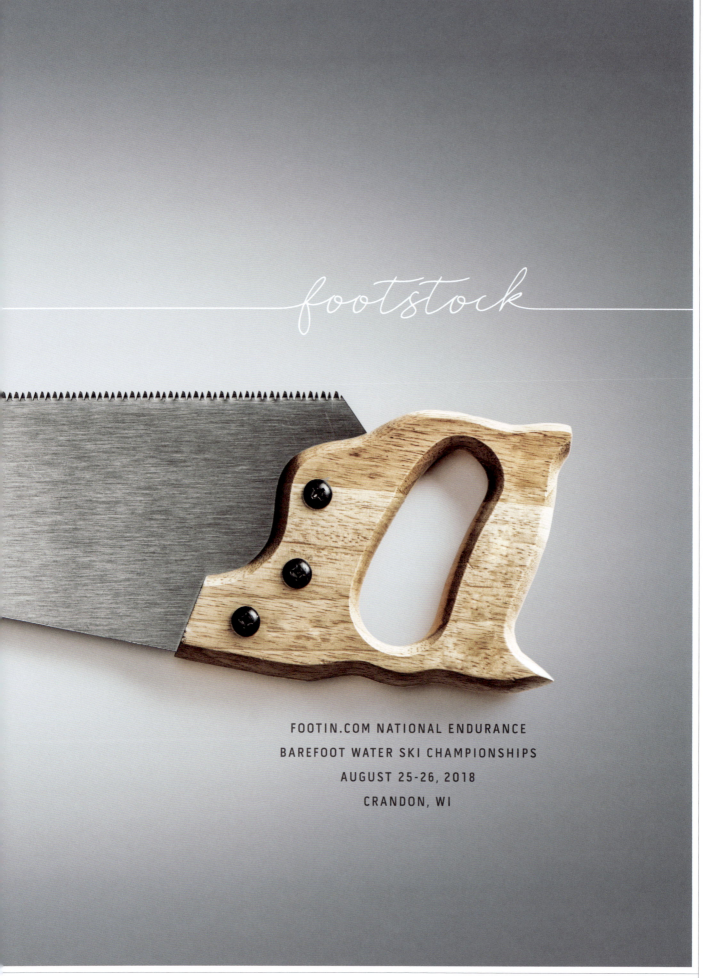

footstock

FOOTIN.COM NATIONAL ENDURANCE
BAREFOOT WATER SKI CHAMPIONSHIPS
AUGUST 25-26, 2018
CRANDON, WI

Saw. Vice President, Creative Director: Scott Krahn; Group Creative Director: Nick Pipitone; Senior Vice President, Cause Marketing: Gary Mueller
Photographer: Anthony Giacomino; Retoucher: Anthony Giacomino; Print Production Director: Rob Birdsall

Introduction by **Steve Lyons** *Director, Maine Office of Tourism*

From the beginning of our relationship with BVK in 2012, it was evident that they looked at things from a different perspective. Their creative approach tapped into the core personal values of individuals planning vacations, moving us away from the staid creatives that had become commonplace among state DMOs. With the newness of the campaign, the Maine Office of Tourism saw first-time visitation increase significantly and consistent year-over-year increases in overall visitation. Their team takes the time to listen to our needs, and they were able to remain nimble during the pandemic even while the travel industry was experiencing unprecedented challenges.

FOOTSTOCK. LET THE PUNISHMENT BEGIN. WBC NATIONAL ENDURANCE BAREFOOT WATER SKI CHAMPIONSHIPS | AUGUST 19-20, 2017 | CRANDON, WI

Workers. Vice President, Creative Director: Scott Krahn; Copy Director: Mike Holicek; Senior Vice President, Cause Marketing: Gary Mueller; Print Production Director: Rob Birdsall

VIEW YOUR MISTAKES AS LEARNING EXPERIENCES RATHER THAN FAILURES. AS THE LATE, GREAT R&B SINGER AALIYAH ONCE SANG, "IF AT FIRST YOU DON'T SUCCEED, DUST YOURSELF OFF AND TRY AGAIN."

Charity Ekpo, *Graphic Designer/Illustrator, BVK*

SOLITUDE AND ADVENTURE SHARE
THE SAME COORDINATES.

All the best parts of winter converge in Wyoming.
Undiscovered trails. Nature at its most epic. And, as
always, the freedom to go find your version of exhilaration.
This is the white-powder playground that asks, "What are
you up for today?" Actually, any answer is a good one.

That's WY

travelwyoming.com // Yellowstone National Park

Wyoming - Solitude. Copy Director: Mike Holicek; Group Creative Director: Matt Herrmann; Executive Creative Director: Brian Ganther
Assistant Production Manager: Stacey Soden; Retoucher: Anthony Giacomino; Photographer: Anthony Bardon

What would you change if you had to do it all over again?

Charity Ekpo (C.E), Graphic Designer/Illustrator: Assuming this is referring to doing my life over again, I'd say stepping out of my comfort zone more often.

Seth Gordon (S.G), ACD: I would go back and learn the importance of disconnecting much earlier in my career. But not at the very beginning; that would not have ended well. I would also have started incorporating more fiber into my diet years ago. The health benefits have been nothing short of miraculous.

Austin Kelley (A.K), Art Director: I had a very nontraditional path to college since I had no idea what I wanted to do. Through that I learned a lot of great things and met some great people, so I don't regret that, but I could have gone through that process more quickly and gotten on the career path sooner.

Ali Coates (A.C), Sr. Copywriter: I'd go to art school. So far my math and zoology skills haven't proved useful in my profession. As much as I still believe I would be a writer, I think exploring my creative side would've served me better than a traditional college degree.

Mike Holicek (M.H), Copy Director: I'd have found a way to control my anxiety. I've worked with creatives who never seem to stress about anything. I'm envious of people who have that level of Zen. Maybe I should've tried hypnosis.

What are the most important ingredients you require from a client to do successful work?

Nicole Irland (N.I), Associate Creative Director: Communication, partnership, and trust make up the necessary foundation in order to create great work. These things open a dialogue and working style that can open up the doors to create memorable, amazing work that everyone had a part in.

Nick Heiser (N.H), Art Director: A clear articulation of the problem and the one thought that needs to be conveyed.

C.E: Great communication, timely and thoughtful feedback, trust, and taking risks are a few that come to mind.

S.G: Strong opinions and a spine. The best work always happens when you're working with people who are honest and willing to take a chance. Whenever clients shy away from the occasional butting of heads or who desperately want to make everyone happy, you know the work will get watered down.

A.K: For me, the most important thing for a client to have is an open mind. Too often they will have a very specific vision in mind and let the work evolve as we go through the process.

A.C: To know their stance and vision. I want to communicate what they believe to be true about their brand. If they aren't sure what that is, neither will I.

What inspired or motivated you into your career?

Nick Marrazza (N.M), Group Creative Director: In the beginning, it was probably something as superficial as the depiction of advertising careers in movies and TV shows. The people that could wear t-shirts, jeans, and Chuck Taylors to work. The ping-pong table. The last minute great idea that won the pitch. And all of those are relatively true. But mostly the motivation was to have a career where I could create something new from nothing. To succeed, to fail, and then do it all over again.

What is your work philosophy?

N.H: Do something every day for your body, mind, and soul. Caring for all aspects of your health allows you to show up as the best version of yourself and do your most creative work.

C.E: View your mistakes as learning experiences rather than failures. As the late, great R&B singer Aaliyah once sang, "If at first you don't succeed, dust yourself off and try again."

S.G: Dig for the truth. Find the problem you need to solve. Keep going until you've solved it.

A.K: I don't know if this is my philosophy or not but I really enjoy making work that works. It's all great and fine to make something pretty, but if it doesn't get the message across then what's the point?

A.C: No amount of polish can hide shitty strategy.

Where do you seek inspiration?

C.E: I seek inspiration from amazing designers, letterers, and illustrators (whether they be in my life or somebody whose work I keep up with online), music, and all the badass women of the world.

N.H: Nature, music, people, film, and art.

S.G: In physical endeavors that pose a risk to life and limb. The focus it demands to wield a chainsaw or operate a log splitter lets you forget about work so your subconscious can do its thing.

A.K: It's easy to jump on Instagram, Dribbble, or Behance and discover great work, but the best inspiration comes from observations in the real world when you aren't looking for them.

A.C: In people's life experiences and stories. I think every idea has to be rooted in human truth, and the best way to find those human truths is to ask, to listen, and to observe the lives happening all around you — especially ones that are different than your own.

Matt Herrmann (M.H), Group Creative Director: I find inspiration in human behavior. This job is about emotionally connecting with people and to do that you have to watch, study, and listen to those around you.

Who were some of your greatest past influences?

Zack Schulze (Z.S), Design Director: As far as designers, my biggest influence would have to be Herb Lubalin. I've always been a fan of the expressive typography of the 60s/70s, and Herb was arguably one of the best. David Carson was another big design influence as well. Other than that, I've been influenced by illustrators and artists like Mike Mignola and Raymond Pettibon, as well as 1970s fantasy/sci-fi artists.

N.H: Derek Vincent Smith, Jerry Garcia, Aaron Draplin, Brett Stenson, and Aubrey Marcus.

C.E: My artistic older sister, I would say, is my past as well as one of my current influences. I LOVED watching her draw, especially when she would allow me to add onto her work with scribbles of my own. I've been in love with art and being creative since I was old enough to hold a pencil and I have her to thank for that.

S.G: The late Kim Rotzoll, head of the Department of Advertising (and later dean of College of Communications) at the University of Illinois. It was sitting in Professor Rotzoll's Advertising in Contemporary Society class that he shared stories of Howard Gossage and opened my brain to the notion that advertising could be more than advertising.

A.K: I was pretty clueless coming into the design world but I was lucky enough to have a teacher, Julie Johnson, who held

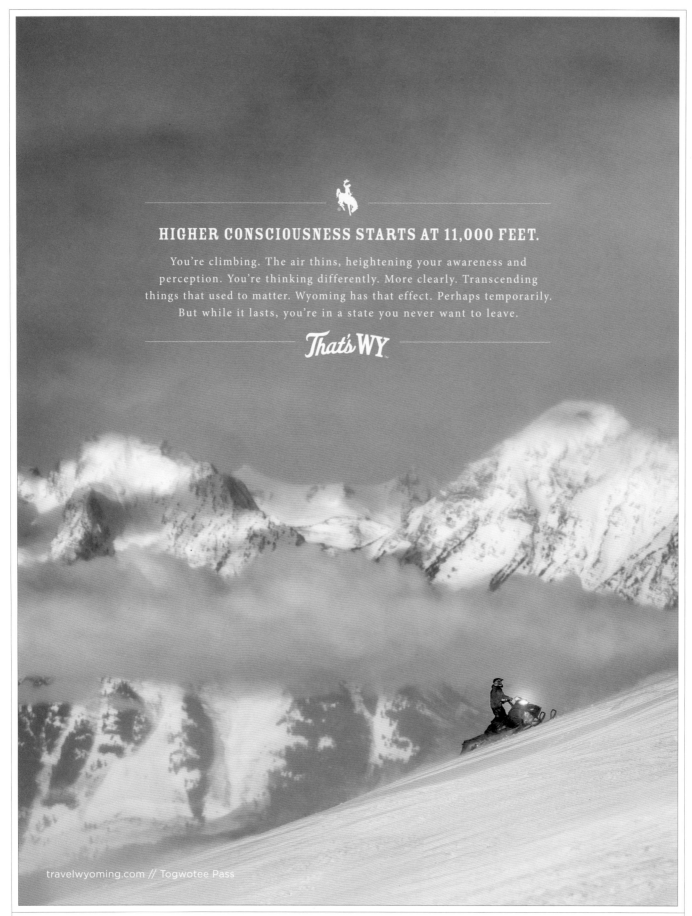

HIGHER CONSCIOUSNESS STARTS AT 11,000 FEET.

You're climbing. The air thins, heightening your awareness and perception. You're thinking differently. More clearly. Transcending things that used to matter. Wyoming has that effect. Perhaps temporarily. But while it lasts, you're in a state you never want to leave.

That's WY

travelwyoming.com // Togwotee Pass

Wyoming - Solitude. Copy Director: Mike Holicek; Group Creative Director: Matt Herrmann; Executive Creative Director: Brian Ganther
Assistant Production Manager: Stacey Soden; Retoucher: Anthony Giacomino; Photographer: Anthony Bardon

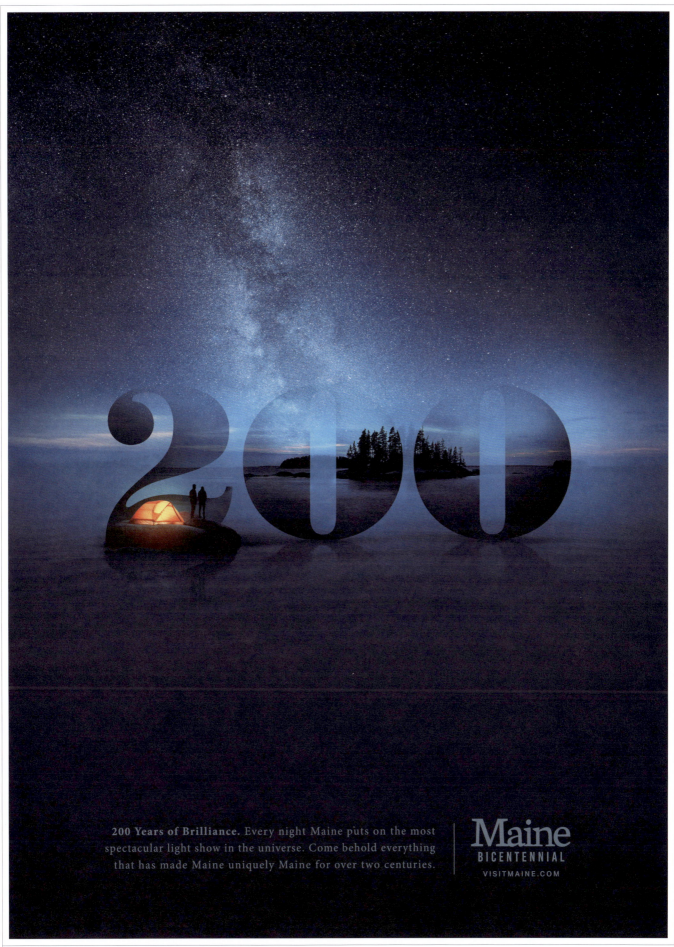

200 Years of Brilliance. Every night Maine puts on the most spectacular light show in the universe. Come behold everything that has made Maine uniquely Maine for over two centuries.

Maine
BICENTENNIAL
VISITMAINE.COM

Maine 200th Dark Blue "Camping" Ad. Associate Creative Director: Katelyn Tierney; Art Director: Katie Parlow; Group Creative Director: Nick Marrazza
Executive Creative Director: Kevin Kriehn; Account Supervisor: Kristin Wood; Print Production Director: Rob Birdsall

us to a high standard and shared some great inspiration with us. I would say my greatest influences were/are Jessica Walsh, Aaron Draplin, and Brian Steely.

A.C: Colleen DeCourcy has been a huge inspiration to me as I continue to grow and seek out female thought leaders in the industry.

I remember coming across an article published in Medium in which W+K adapted a version of a speech she gave at D&AD in London titled "How To Catch Lightning in A Bottle." I come back to that piece every couple of months. Incredibly smart, inspiring, and thought-provoking.

What part of your work do you find most demanding?
S.G: Lately, one of the most demanding parts of my work is making the most of an ever shrinking canvas. As clients rely more heavily on small or oddly-configured digital units and broadcast lengths, writing to fit them in a way that still captures the essence of a brand and our big idea has turned writing into an ever-evolving sequence of word puzzles. Where we once were called upon to tell stories or develop interesting narratives, we're now playing a game of conceptual Boggle.

What professional goals do you still have for yourself?
S.G: Professional goals I still have? I would love to breed and race sled dogs. Oh, wait, does it have to be in this industry?

What interests do you have outside of your work?
What do you value most?
Kia Namin (K.N), Copywriter: I came to copywriting out of a love for language, so when I'm not working I'm usually reading and working on my own stuff. Above all other forms of writing, I value poetry the most. There's something about the density of good poetry that gets closer to capturing the density of experience and feeling than prose. But when a novelist pulls it off, I go wild. (See: Marilynne Robinson, Lauren Groff, James Salter.) When my brain is done for the day, I'll ride my bike so I don't get my ass completely kicked when I race on the weekend.

How do you define success?
Mike Holicek, (M.H) Copy Director: Success is looking back at the end of a year and thinking, OK, I hit a handful of home runs and I struck out a little less than the year before. Basically, just feeling like I still have game even in my advancing years.
Matt Herrmann, (M.H) Group Creative Director: I define success as falling asleep at night in under one minute. It means I've worked hard enough that I'm physically exhausted but mentally my mind is at peace.
Nick Marrazza (N.M), Group Creative Director: Success is

pride in a job well done. At the end of the day, do you want to share your work with your peers? Do you want to share it with people who don't work in advertising? Are you proud of it? If so, then you're succeeding.

What advice would you have for students starting out today?
Katrina Moenning (K.M), Graphic Designer: My advice for students would be to enjoy your creative journey, accept that your growth will always be an ongoing process, and know that a strong work ethic will pay off in the long run. Surround yourself with other creatives who can build you up. Always stay humble and hungry.

Who among your contemporaries today do you most admire?
Katie Parlow (K.P), Art Director: Jessica Walsh. Her style is super strong, bright, unique, and bold. The work she does is always pushing the boundaries and on the edges of being "weird" in the most elegant way. Her Instagram is always a source of inspiration and a reminder to keep pushing my personal style.

Who have been some of your favorite people
or clients you have worked with?
A.K: The thing I appreciate most whether working with a co-worker or a client is the ability to break down barriers and truly collaborate on a brand. We get to a place where both sides feel comfortable challenging the other to push the work forward. It's from this place where the brand can grow and evolve down a strategic path over time.

What is your greatest professional achievement?
A.C: I would say my greatest professional achievement was when I started to realize I could affect the culture of my agency. The client work will always be undoubtedly important, as is making work you're proud to put in your book.

But speaking up, reaching out, and getting involved was hugely beneficial to my career. When you don't feel "stuck" in an environment and learn that your voice is something people actually want to hear more of, and realize that using it actually can shift culture and dynamics – it opens up a space for endless creativity. Not just for yourself, but for your team as a whole.

What makes BVK stand out among your contemporaries?
Kate Tierney (K.T), ACD: The "can-do" culture. Although we are a small agency in the heart of the Midwest, the spirit, tenacity, and talent that lies within these walls is that of a global agency.

BVK www.bvk.com

COMMUNICATION, PARTNERSHIP, AND TRUST
MAKE UP THE NECESSARY FOUNDATION IN ORDER
TO CREATE GREAT WORK. **Nicole Irland,** *Associate Creative Director, BVK*

Bofferding. Associate Creative Director: Brian Steinseifer; Group Creative Director: Nick Marrazza; Executive Creative Directors: Brian Ganther & Kevin Kriehn
Print Production Director: Rob Birdsall; Photographer: Lucian McAfee

Imported from Luxembourg.
Exported in Wisconsin.

Bofferding. Group Creative Director: Nick Marrazza; Executive Creative Directors: Brian Ganther & Kevin Kriehn
Print Production Director: Rob Birdsall; Associate Creative Director: Brian Steinseifer

WORKING WITH BVK WAS SEAMLESS. THEY REALLY TOOK THE TIME TO RESEARCH AND UNDERSTAND OUR PLACE. IT RESULTED IN A CAMPAIGN THAT'S INSTANTLY RECOGNIZABLE AND TELLS THE STORY OF OUR BRAND BY HIGHLIGHTING ITS ALL-NATURAL INGREDIENTS IN A FUN WAY.

Rob Ebert, *Marketing Director, Ansay International*

KIDS HAVE FEARS. **WE REMOVE THEM.** The Children's Hospital at OU Medical Center

Kids can imagine the worst when it comes to a hospital visit. That's why The Children's Hospital has Child Life specialists, trained to show them that what they think is often scarier than what's real. So they can feel safer during their stay. Here an experienced team of doctors, nurses and staff are trained in pediatric medicine, using equipment and procedures designed specifically for children. And our drive to bring the latest advances means even greater peace of mind. Show your child what to expect at **GoodbyeFears.com**.

KIDS HAVE FEARS. **WE REMOVE THEM.** The Children's Hospital at OU Medical Center

You'd be surprised what a child can imagine a hospital to be. So treating kids starts with helping them understand medical terms, and helping prepare them for what to expect. At The Children's Hospital we're experts at taking away the anxiety. We specialize in the unique needs of children, using equipment and techniques designed just for them. And our research puts us at the forefront of the smartest new ideas and innovations for keeping kids healthy. Show your child what to expect at **GoodbyeFears.com**.

OU Medical Center. Creative Director/Copywriter: Mike Holicek; Executive Creative Director/Art Director: Rich Kohnke
Assistant Production Manager: Stacey Soden; Photographer: Nick Collura; Retoucher: Jim McDonald

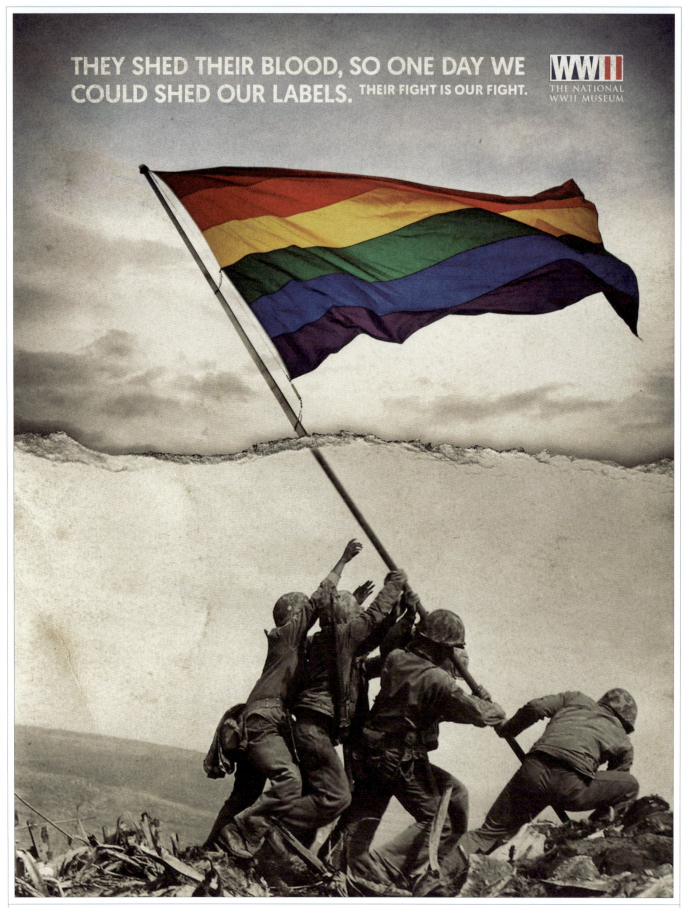

WWII - National Museum Speculative Work "Flag". Associate Creative Director: Brian Steinseifer; Copy Director: Mike Holicek
Executive Creative Directors: Brian Ganther & Kevin Kriehn

PHOTOGRAPHY

Erik Almas: Input Equals Output

ERIK ALMAS' PHOTOGRAPHY STYLE SURPASSES GENRES AND ALWAYS PRESENTS A UNIQUE STORY.

Tatijana Shoan, *Editor-In-Chief/Photographer, As If Magazine*

ERIK IS A MIRACLE WORKER WHO HAS PULLED OFF AMAZING IMAGES FOR GENLUX. HE HAS AN INCREDIBLE EYE FOR DETAIL, AND LIKE ALEX HONNOLD FREE-SOLOING EL CAPITAN, HE REFUSES TO SLIP-UP ON THE TASK AT HAND.

Stephen Kamifuji, *Founder/Creative Director, GENLUX*

THERE IS AN ELEGANT GRACE TO ERIK'S WORK. THE IMAGES DRAW YOU IN WITH A WHISPER THAT COMPELS YOU TO TAKE A LONG BREATH AND LINGER IN HIS WORLD FOR A WHILE.

RJ Muna, *Photographer, RJ Muna Pictures (Graphis Master)*

ERIK IS A TRUE FINE ARTIST, FROM "PAINTING" ORGAN TRANSPLANT SURVIVORS IN THE STYLE OF THE RENAISSANCE MASTERS TO LAUNCHING A ROSÉ WITH A TIMELESS FRENCH AESTHETIC.

HIS WORK REFLECTS THE DEPTH OF SOUL AND IMAGINATION HE BRINGS TO EVERY COLLABORATION.

Amber Justis, *Creative Director, The Justis Department*

ERIK'S CREATIVITY AND VISION BRING CONCEPTS TO A NEW LEVEL OF BEAUTY AND RICHNESS. HE IS INTIMATELY INVOLVED WITH EVERY DETAIL FROM THE BEGINNING TO THE END, AND IT SHOWS IN THE QUALITY OF HIS WORK.

Meredith Ott, *Founder, Alice Blue*

(Page 67) Captured for Newport Beach Tourism. Our inspiration was Cleopatra and how she would be treated in this beach town where "high tide meets high style." (Above) Nude Study. Personal work

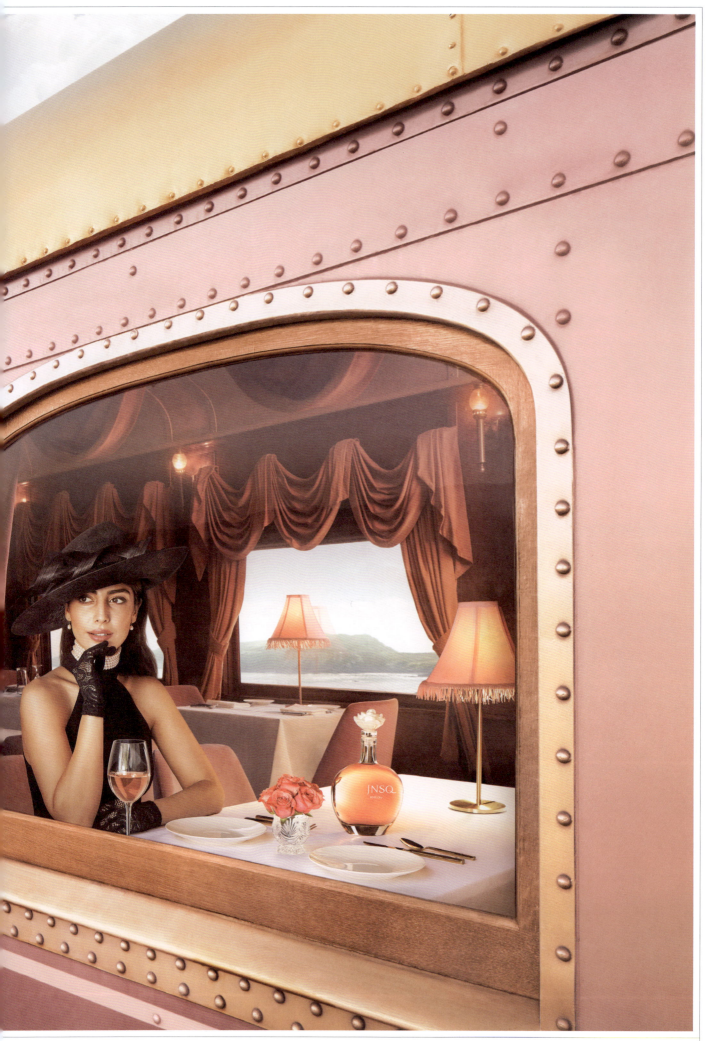

JNSQ is a "California wine with a French twist". The images were inspired by the same mix of California Coll and French sophistication.

Introduction by **Jim Erickson** *Photographer, Erickson Stock*

Erik Almas came to me right out of school. He is from Norway, and I had a soft spot for this young and ambitious photographer. From a perspective of an established photographer and employer, I could tell right away that Erik had many gifts. He listened, paid attention, never said no, and put in an honest day's work. But what really stood out about Erik was that he loved photography and was passionate about learning the art and craft of this complex business, and with me, that's what counted most. Erik and I worked together for almost five years and there were a lot of good times, hard work, and laughs. Everyone loved Erik's foreign accent and his sensitive approach to life. I taught Erik everything I could photographically at the beginning of the Photoshop revolution. Erik seemed to love the magic he could create with the computer and worked on his own stuff. As the years progressed, his work got better and better, and when it came time for Erik to strike out on his own, he had a huge photographic vocabulary and a great eye for composition. Erik relates to people in a positive way, and people trust his vision. Erik had the tools and all the right ingredients. I'm glad to see he's done so well. It's a testimony that hard work really does pay off.

JNSQ is a "California wine with a French twist". The images were inspired by the same mix of California Coll and French sophistication.

THE HEART OF THIS PROCESS IS TO CREATE THAT INTANGIBLE QUALITY OF A TRUE MOMENT WHICH REALLY MAKES THE VIEWER FEEL SOMETHING WHICH TRANSCENDS THE TWO DIMENSIONAL SURFACE OF THE IMAGE. **Erik Almas,** *Photographer*

Absolut

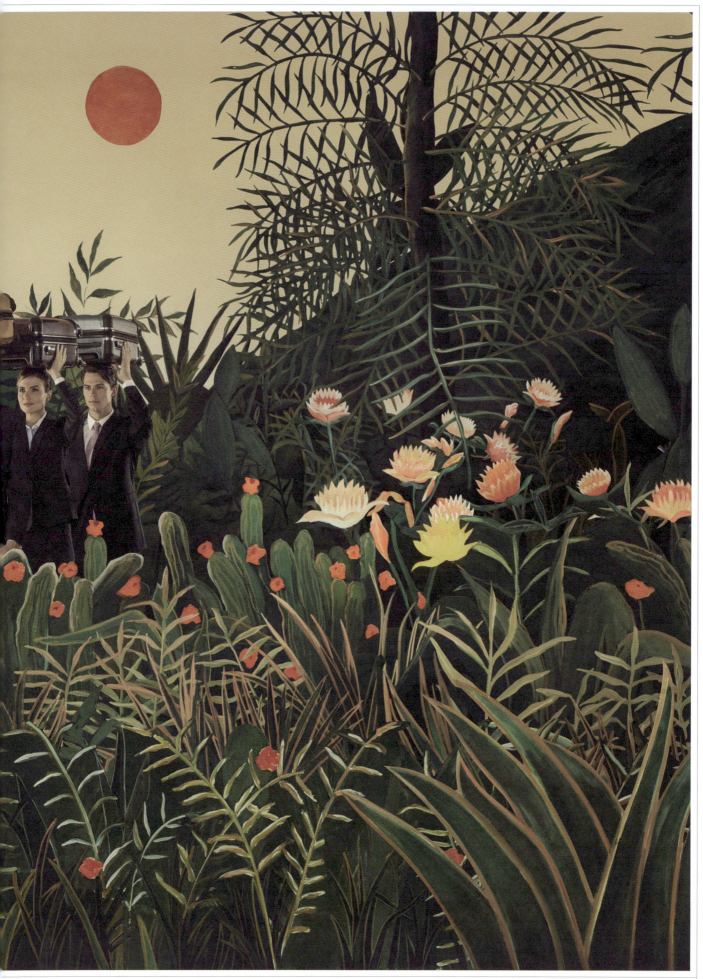

Credit Suisse - Tumi

What inspired or motivated you into your career?
Some great friends, a passion for skiing, and having to make a career choice. Photography was not an obvious choice for me. It was, however, a small part of other things I did and through those things, I got introduced to taking pictures.

At twenty-two, I felt myself drifting and unsure of what to do with my life. Photography was the only thing which really got me excited, so I decided to take a swing at photography as a profession. Through some serendipitous events I found myself on my way to San Francisco just a few months later to study at the Academy of Art University.

What is your work philosophy?
To create compelling work with a quiet sense of beauty and to do so with tenacity and grace.

Where do you seek inspiration?
Everywhere and nowhere, but more and more in books and poetry. I believe that input equals output. For me to be inspired, I have to expose myself to things which I find to be inspiring. People, places, experiences, movies, and galleries all give me inspirational input which might spark an idea or a visual. I then feel compelled to create. What's important is to allow space for this spark and creative output to happen. Running and reading books and poetry creates space for me.

What aspect of photography do you most enjoy?
The experience of it. It's one part more than another, but the experience of crafting an image and narrative from idea to a final tactile print.

How would you describe your process?
The practical process of my images is often layered. I capture elements and then build my images from the background forward, capturing the parts and elements needed to build a compelling final photograph.

My creative process is random, but similar; one thing or idea can inspire or attach itself to another idea, or maybe a place or a person or a memory, and through these layers of inspiration, images and stories start to emerge.

What has been your most memorable project?
I have taken some of my more memorable images on the street outside my house, yet my favorite experience taking pictures might be helicoptering into a storm in the mountain peaks around Queenstown, New Zealand.

I have been blessed with so many great projects and it is not possible to rank the experiences. I have dived in ocean caves, I have rappelled into underground chambers, I have been to deserts and climbed to mountaintops all in search of the perfect location. I have photographed from helicopters and while skydiving, and even photographed a 777-200 while flying around it in a small Learjet.

Who is or was your greatest mentor?
Jim Erickson.

Can you tell us about your time at the Academy of Art University and how it shaped the path of your career?
The Academy of Art University was a great place for me. I started with the intention of staying for a couple of years, wanting to learn just enough to continue on my path to become a sports photographer. Through a passionate group of teachers, (especially Susan Schelling), I got completely absorbed in the art and craft of photography.

Parallel to my photography I would take one computer arts class every semester. By my graduation in 1999, I had shifted from the traditional to the digital darkroom and became a part of the first generation of photographers who used the computer as a natural extension of their image-making process.

What is the most difficult challenge you've had to overcome?
Making a living as a photographer …

What is your proudest professional achievement?
Being included in the National Portrait Gallery's Taylor Wessing Portrait Prize.

And being part of one of the most storied campaign in advertising, shooting three images for Absolut Vodka with TBWA/Chiat/Day.

Who among your contemporaries today do you most admire?
There are so many artists and photographers who I admire, but the two I refer back to most are Nadav Kander and Tyler Gourley.

I am increasingly intrigued by cinematographers. Emmanuel Lubezki, Roger Deakins, and Paul Mayers are some of my cinematic heroes.

Many of your photos tell a visually rich story. Do you conceptualize the story before the shoot or does the story emerge after working with the subject?
The idea and story comes first. Around the initial idea we start making/building the visual by considering location and talent. Where does this happen and who is the protagonist? What light and color palette best support the story? What are the props or other elements needed? With these parts and crew in place, we capture the image. The story often evolves and deepens when working with the subject on set, but the building blocks are all established prior to the shoot.

For some of my personal work, however, it can at times be the other way around where the place can inspire the story. I can come upon a landscape and as I photograph, start pondering what might have happened in this place prior to me taking these images. Who has been here before me? What were they like, what did they do, and what encounters did they have?

Through this pondering, a narrative starts building, and I will use this to later capture the talent and add it into the landscape.

What part of your work do you find most demanding?
At this point in my career, I consider myself a craftsman fluid in my craft. As the practical process of capturing images has become second nature, the real challenge is infusing the images with the intangible elements of feeling and emotion. The most demanding part of the process by far is to create the genuine within a frame that's crafted; to give or find meaning within the connection between me and the subject.

What professional goals do you still have for yourself?
To continue to deepen my craft both as a photographer and director. The heart of this process is to create that intangible quality of a true moment which really makes the viewer feel something which transcends the two-dimensional surface of the image.

Created for Saatchi Wellness in a campaign where one would not let oneself be run over by a truck.

(Above) An images created for Sheraton Hotles. Their tag line was "Going Beyond", and in this series of images we climbed mountains and crossed the ocean, the desert, and the West to go above and beyond for their guests. / (Opposite page) JNSQ is a "California wine with a French twist". The images were inspired by the same mix of California Coll and French sophistication.

I would suggest three things: find what you are deeply attracted to. This means spending some good time with minimal distractions to let your true desires as an image-maker surface.

Get a mentor to help guide you on your path. Put down your phone and focus on creating rather than wasting time comparing yourself to others on social media.

What interests do you have outside of your work?
My family, running, and to design and build spaces.

What do you value most?
My family. And my health.

I know that you live in San Francisco, but are originally from Norway. Do you ever take time to shoot in Norway as well?
Yes, but it is increasingly as the token family photographer.

How do you define success?
To evolve gracefully as a photographer and director, and a husband and father. (This said, I did write a blog about success and "having made it" after our home almost burnt down in the Sonoma fires of 2018.)

"Experiencing the certainty of losing my home and how that realization affected me created a shift in my perspective on success and what having 'made it' is. In no particular order, and without being right for everyone, here's a work in progress short list of what now resonates with me and the idea of 'making it':

If you keep your focus on creating, you have made it. If doing what you do expands you and fills you up, you have made it. If you crave creating every day, you have made it. If you are excited about what you just created and even more excited to improve upon it, you have made it. If you are proud to show your work, you have made it. If you found an expression that consistently expresses who you are, you have made it. If you have done the above so consistently your expression starts to recognize itself, you have made it. If you question why and how and who and explore this through your work, you have made it.

So my shift and lesson is this: you can celebrate your successes like Bill Burr, but don't attach them to an event, a monetary item, or any other social measure of success. This will yield nothing but downward pressure and distractions to the significance of creating something which deeply resonates with your being. It will leave you feeling like you are coming up short every time. Which in turn will make you want to give up." blog.erikalmas.com/2017/11/12/what-if-your-house-burnt-down/.

What would you change if you had to do it all over again?
I don't think I would change anything. I truly believe I have been shaped by my mistakes more so than my successes. Without the struggles and mistakes I don't think I would be where I am today. I would for sure not know myself in the same way if I changed the path that led me to who and where I am today. So I would take on all those mistakes again if I had to.

What would be your dream assignment?
For a long time, it was to photograph the cover of Vanity Fair. Today it would be any assignment which truly challenged me creatively.

Where do you see yourself in the future?
Where I am today; being with my family and passionately creating images and films but with the vibrancy of a twenty-year younger self.

Erik Almas www.erikalmas.com
See his Graphis Master Portfolio on graphis.com.

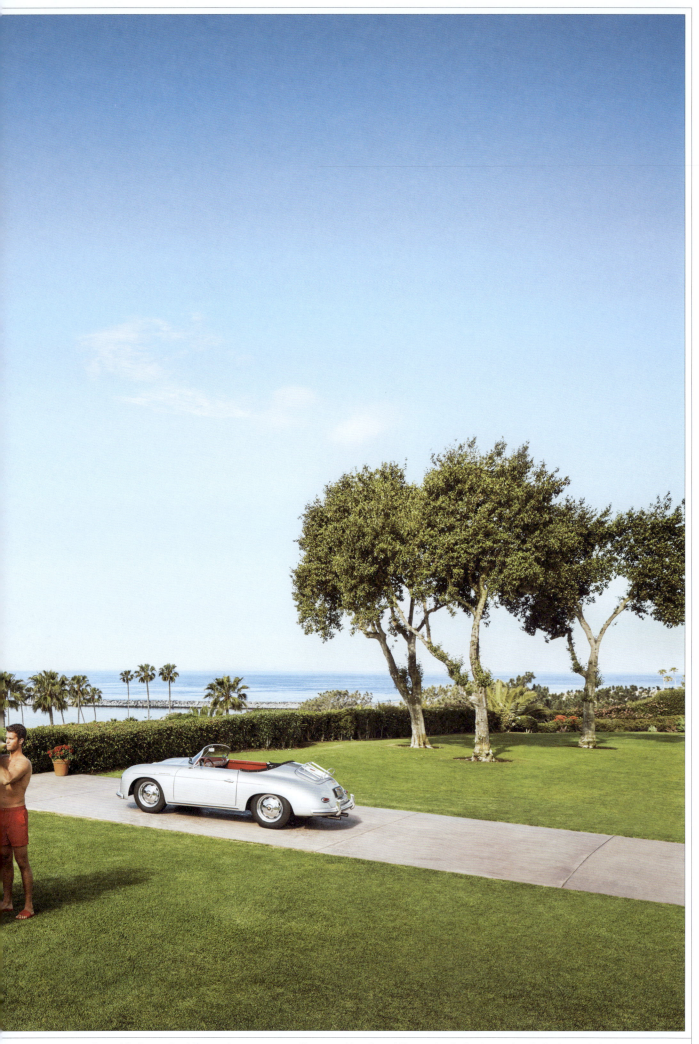

Captured for Newport Beach Tourism. Our inspiration was Cleopatra and how she would be treated in this beach town where "high tide meets high style."

Colin Faulkner: Searching for Sculptural Aspects

WORKING WITH FAULKNER ON THE LANGDON HALL COOKBOOK WAS A REMARKABLE EXPERIENCE. HIS ABILITY TO DRAW OUT DETAILS THAT MADE US SEE THE PROPERTY IN WAYS WE HAD NEVER CONSIDERED WAS NOTHING SHORT OF MAGICAL.

HE IS A TRUE PERFECTIONIST, ALWAYS FULL OF CREATIVE SOLUTIONS AND A DELIGHT TO WORK WITH. HIS STYLE AND AESTHETIC WAS ON BRAND WITH OURS. THE FINAL PHOTOGRAPHY FOR THE COOKBOOK FAR EXCEEDED EXPECTATIONS.

Braden Bennett & Jennifer Houghton, *Managing Directors, Langdon Hall/Relais & Chateaux*

HE IS AN ARTIST BEFORE HE IS A PHOTOGRAPHER. HE ENVISIONS AN IMAGE BEFORE HE HAS EVEN FRAMED IT UP IN THE CAMERA AND METICULOUSLY REFINES THE MOOD BY PAINTING IN THE LIGHT. HE NEVER CEASES TO AMAZE BY ALWAYS TAKING ANY PROJECT TO THE NEXT LEVEL.

Sandy Kim, *Principal and Creative Director, Aperkoo*

AS A TESTAMENT TO HOW "THE SIMPLEST THING IS THE HARDEST TO DO," HIS WORK SHOWS US THAT PHRASE'S MEANING. A MASTER OF ADDING DIMENSION, AT FINDING COMPOSITION, AND CREATING ART FROM OBJECTS—HE WAS THE OBVIOUS CHOICE TO REPRESENT THE KLAUS FORMS WORK.

Scott Leder, *Creative Director, VOLTA*

Miu Miu. Client: Holt Renfrew; CD: Sandy Kim; Stylist: Jay Barnett; 2014.

Introduction by Diti Katona *Co-founder, Partner, and Chief Creative Officer, Concrete*

"You're such an old lady," I would often taunt Colin. I've known him long enough to say this to him. But he never responds. Not because he's offended, or a pushover. He just doesn't care. Because when he's in his zone – contemplating, assessing, evaluating – all that matters is the shot and getting it just so. The result is always more than I imagine. It's not just that he can take a complex composition and style and light it impeccably. Many can do that. What is more amazing is his ability to draw something great out of the mundane. Colin can take the most commonplace object and make it so uncommon.

6.15.50 am. 2005.

I DELIVER WHAT IS ASKED — AND THEN
I CHALLENGE MYSELF AND THE TEAM TO PUSH THE
BOUNDARIES FURTHER AND MAKE IT BETTER.

Colin Faulkner, *Photographer*

Hindmarch. Client: Holt Renfrew; CD: Sandy Kim; Stylist: Jay Barnett. 2016.

What inspired or motivated you into your career?
I always knew I would work in a creative field. Initially, I thought it would be ceramics and sculpture, but I decided against being covered in clay and dust all day. Photography was an early and constant presence in my life. In grade school, my older brother helped me construct a pinhole camera and develop the image for a project. My father, an avid amateur photographer, documented our life and travels in Asia through photography. Witnessing my father's passion ultimately led me to minor in photography at art school – and it was there that I started to experiment with the immense scope of the medium.

Who is or was your greatest mentor?
Diti Katona is the creative director and founder of Concrete Design. She has been one of my greatest mentors, and still is. Over the years, she and her team have come to me again and again with only the germ of an idea, and together we've raised the bar and found new ways to create inspiring images.

What is your work philosophy?
To deliver what is asked – and then to challenge myself and the team to push the boundaries further and make it better.

What has been your most memorable project?
I've had many memorable projects through the years. One of the most immersive was working on a Relais & Chateaux cookbook. We shot over four seasons: portraits, environments, still lifes, and of course, the food! It was a year full of adventures, personalities, animals (chickens, hawks, lambs, pigs, longhorns, bees!), vegetables, and rich experiences. And it was invigorating to work closely with the subject and client, who was completely motivated to be involved in our process and eager to collaborate every step of the way.

Why do you stage your photographs in such a minimalistic manner?
I see "things" as scuptures. Whether it's food, fashion, cosmetics, furniture, or accessories, I seek out the sculptural aspects in the objects I photograph and ideally want the viewer to experience these aspects without other competing elements. Too many components in a photo can confuse the eye; I want the viewer to be drawn in and focus on the main object while being able to appreciate the surroundings. But for every rule there is an exception, and sometimes having chaos surrounding an object achieves the desired effect.

What is the most difficult challenge you've had to overcome?
My pursuit of perfection used to take away the satisfaction of a job well done and made it difficult for me to communicate excitement in the work. I'm rarely fully satisfied with the results and am constantly trying to push it. While perfectionism in itself is not bad, it can make it harder for me to "sell" it to clients.

Who were some of your greatest past influences?
Irving Penn, Peter Lindberg, and Albert Watson.

What would be your dream assignment?
I am drawn to craft, whether it is an individual creating unique objects, a chef cooking beautiful food, or a company that believes in authentic, thoughtfully designed, well-made products in any category. Working on a project with one of these clients over a period of time that involves total immersion in their creative process would be incredible.

Who among your contemporaries today do you most admire?
As my work evolves, this constantly changes for me. I currently admire Ditte Isager and Gentl and Hyers for their ability to achieve a balance between still lifes and beautiful environmental imagery.

Do you approach personal projects differently than commercial/commissioned photography? How so?
Some of my personal work can be very abstract and without a main focal point. I tend to visualize these projects as I would a painting or drawing. Some commissioned work can be similar if they are conveying a concept, though most commercial projects tend to be focused on selling an object.

Who has been some of your favorite people or clients you have worked with?
Concrete Design, Perricone, Klaus by Nienkamper, Langdon Hall/Relais & Chateaux, and Holt Renfrew.

What is the greatest satisfaction you get from your work?
I get satisfaction from working with incredibly talented people and collaborating as a team to achieve the best and most creative results.

What part of your work do you find most demanding?
The most demanding aspect of my work is translating the client's words into the lexicon of photographic language. For example, a client may say they would like the images warmer, which sometimes translates to less depth of field, but may also mean more props or simply warmer light or color.

What advice would you have for student photographers starting out today?
To be creatively successful, you have to live fully in the path that is natural to you. This passion is what will make your work stand above others.

What interests do you have outside of your work?
I am constantly working on personal creative projects: painting, ceramics, installations, and of course sculptural forms. Plus cooking, which is another art I love to work in.

What do you value most?
Honesty, humbleness, collaboration, and creativity.

Where do you seek inspiration?
Everywhere. You have to keep your eyes open, as you never know when something will trigger an idea or way of visualizing.

How do you define success?
I define success as seeing your work produced in a visually compelling fashion that marries your photos with great design, and having people you admire come back to you for more.

Colin Faulkner www.faulknerphoto.com
See his Graphis Master Portfolio on graphis.com.

Miss Dior. Client: Hudsons Bay Company. 2013.

African White Backed Vulture. Kenya, 2019.

Peter. Client: Unitron; CD: Sandy Kim. 2011.

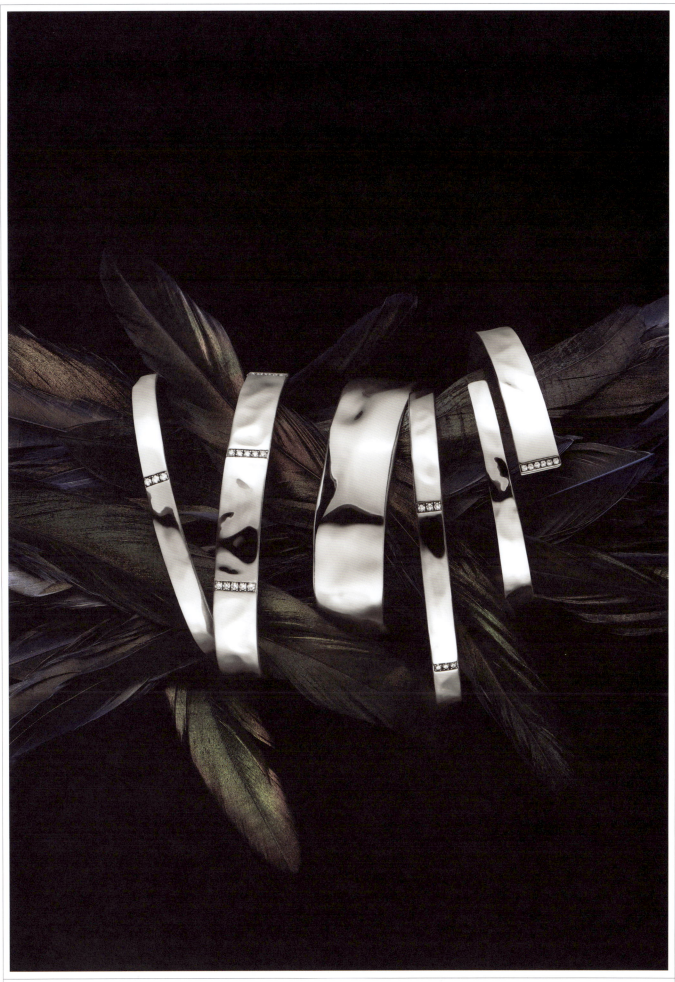

Ippolita Bangles. Client: Holt Renfrew; CD: Sandy Kim; Stylist: Jay Barnett. 2016.

Horse. France, 2015.

(Opposite page) Elements of Beauty. Client: Holt Renfrew; CD: Sandy Kim; 2015. / (Above) Flowers. 2015.

Kite + Demarco. Stylist: Alanna Davey. 2017.

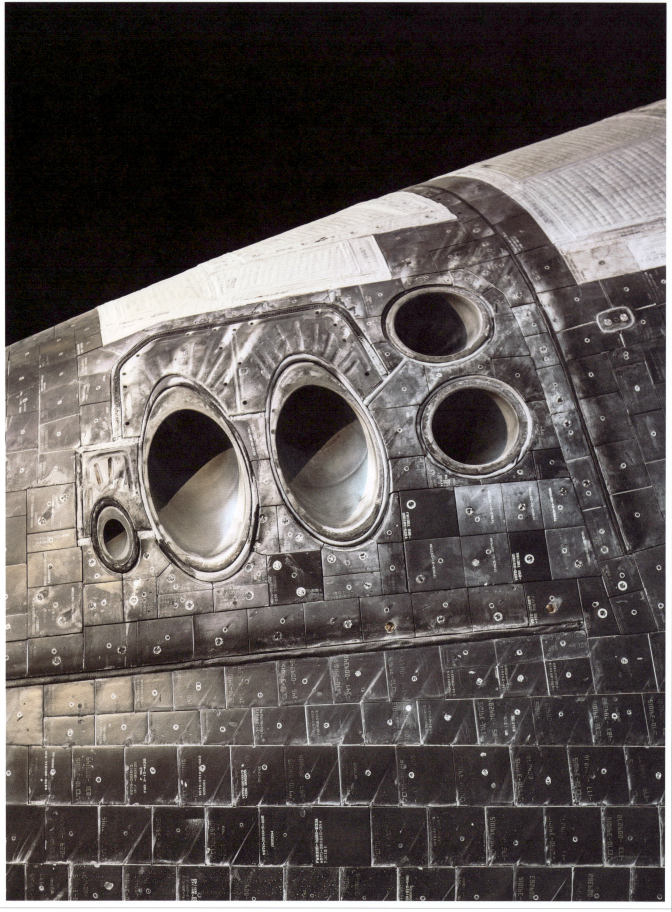

Space Shuttle Discovery (01). Washington, 2019.

ART/ILLUSTRATION

Daniel Pelavin: A Vintage Style of His Own

DANNY IS ONE OF THE MOST INVENTIVE, PROLIFIC, AND ENTHUSIASTIC GRAPHIC ARTISTS. DANNY'S WORK IS ALWAYS STAMPED WITH HIS SINGULAR COMBINATION OF IMAGINATIVE IMAGERY, A RICH COLOR PALETTE, AND AN UNEXPECTED JUXTAPOSITION OF TYPOGRAPHY.

Kit Hinrichs, *Principal and Creative Director of Studio Hinrichs*

ALTHOUGH OUR WORK HAS MANY TRAITS IN COMMON, I HAVE ALWAYS BEEN SURPRISED AT HIS ABILITY TO DISTILL HIS WORK DOWN TO A SIMPLICITY THAT I'VE NEVER BEEN ABLE TO ACHIEVE.

THAT AND HIS UNIQUE VISION OF FORM AND COLOR HAVE KEPT ME COMING BACK TIME AFTER TIME TO ADMIRE HIS LETTERFORM WORK.

Michael Doret, *Graphic Designer and Lettering Artist, Michael Doret Graphic Design*

DANNY PELAVIN INSPIRED ME EARLY ON WITH HIS FULLY-DEVELOPED STYLE AND HIS IMPRESSIVE KNOWLEDGE OF PRODUCTION. HE ALWAYS BRINGS HIS ART TO ITS FULL SPLENDOR. I ADMIRE HIS SENSE OF HUMOR AND HIS OUTSTANDING THUMBNAIL DRAWINGS.

Gerard Huerta, *Graphic Designer and Illustrator, Gerard Huerta Design, Inc.*

DANIEL PELAVIN HAS THE UNIQUE ABILITY TO CAPTURE THE RETRO QUALITIES OF TYPE AND LETTERING AND BRING THE PAST ALIVE, WHICH HE HAS ACHIEVED CONSISTENTLY FOR OVER FOUR DECADES WITH GREAT SKILL, CHARM, AND PASSION.

Louise Fili, *Creative Director and Graphic Designer, Louise Fili Ltd.*

(Page 97) Cover, The Flying Book by David Blatner / (Above) Vincent Black Lightening Illustration, Society of Illustrators Exhibition

Introduction by **Mary Zisk** *Design Director, Strategic Finance*

Could anything be more boring than a survey of accountants' salaries? Fearless Danny Pelavin didn't think so. For fifteen years, he tackled the annual salary survey cover of Strategic Finance Magazine as if he had never designed the words before. Each year, I would receive bold, wiggly thumbnails from Danny, and I knew I could trust that those squiggles would turn into a dynamic, stunning cover. His designs reflected his vast knowledge of the history of typography, and he explored the best of each era. Knowing Danny since the days of ruling pens and French curves, I'm delighted by how he continues to challenge himself creatively.

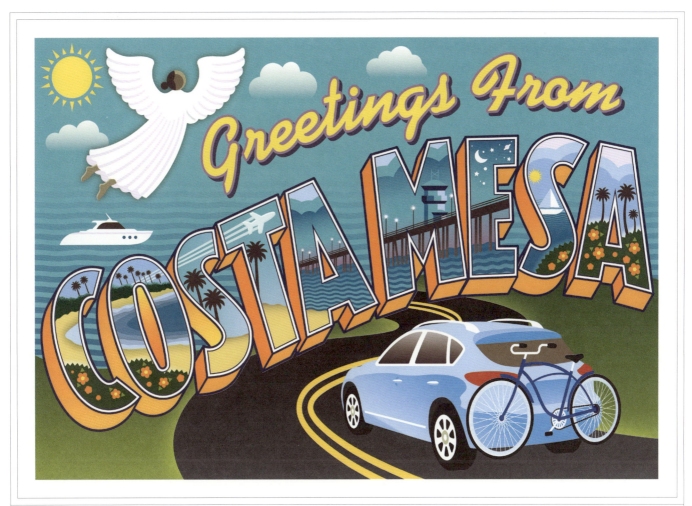

Costa Mesa CA, Guideposts Magazine

I DON'T TRY AND KEEP TRACK OF "ACHIEVEMENTS."
I PREFER TO JUST BE GRATEFUL FOR ALL THE
OPPORTUNITIES THAT I'VE BEEN GIVEN.

Daniel Pelavin, *Illustrator and Typographic Designer*

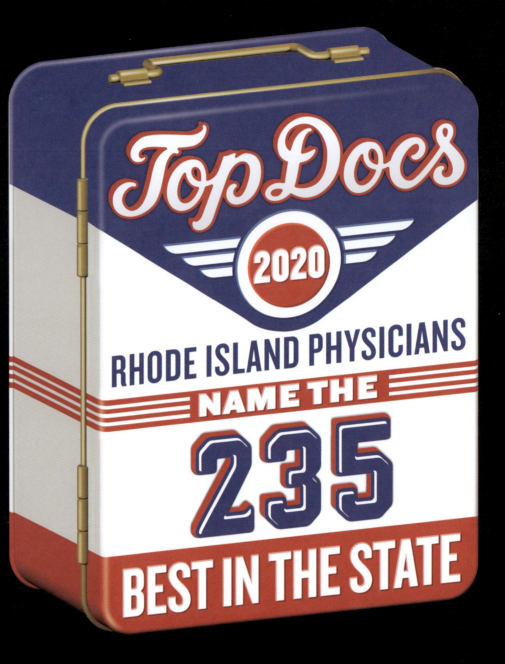

What is it about design that you are most passionate about?
I am most passionate about the opportunities design provides to transcend the encumbrance of mere language by incorporating a vast array of assets which tap into our intuitive sense of culture and history.

You work in illustration, typography, and icon design.
Which of the three is your favorite and why?
I don't make distinctions between the three. They're each about putting marks down to advance communication and understanding, and frequently overlap.

What inspires or motivates you in your career?
I consider this "career" an amazing gift, so I think I am motivated by appreciation. Also, there are no other "careers" I'm willing to pursue.

Which project/piece(s) is your favorite and why?
There are works with which I'm very satisfied and plenty that I'm less so, but it's tricky to pick favorites. I'm actually surprised to find so many that I don't hate.

What is the most difficult challenge you've had to overcome in your career and why? How has it impacted your career?
The challenge of keeping art directors and designers from sabotaging their own projects. It has caused me to put a lot of effort into communicating more effectively.

On your website, it says you trained as an apprentice in local art studios, and that played a big role in your art education. What was that like, and how did it help develop your work compared to school?
It was incredible, like discovering a whole new universe in which I was meant to exist after twenty years of denying the possibility. I was an errand boy, mat cutter, palette washer, and water bowl filler for a studio full of insanely gifted artists, illustrators, and designers who were working for their livelihoods rather than grades.

You use a lot of 20th-century forms, colors, and typeface. What draws you to using these style elements?
It's the century in which I grew up and the forms that surrounded me and captured my attention as I searched for the meaning of life.

You've written many articles on design practice and education. Which article is your favorite and why?
Which one do you think all design students should read?
"No art director ever asked to see my diploma" from the book *The Education of an Illustrator* by Steven Heller. I think that one along with *Make it Bigger* by Paula Scher would be of use for students.

You've also presented your work at different design organizations and universities. Which presentation has been your favorite and why?
I must say I've enjoyed every opportunity to engage with students and fellow designers. However, there was a very memorable visit to Oklahoma where I did one evening in Oklahoma City and the next in Tulsa. I was truly amazed at the vastly different character of those places less than two hours apart on US 44. A particularly touching moment was when the folks in OC proudly pointed out the glitter that still remained in the auditorium from a visit the previous year by my friend the illustrator José Cruz.

Who were some of your greatest past influences?
I think my mom, who encouraged me to follow my dreams in the face of a world where they weren't judged as practical. Oh, are you asking for influences by other artists? Too many to mention, but I'll try. In no particular order: Lucien Bernhardt, Ludwig Hohlvein, AM Cassandre, Charles Rennie Mackintosh, Oswald Cooper, Edward McKnight Kauffer, Will Bradley, Alphonse Mucha, Gustav Klimt, Egon Schiele, Aubrey Beardsley, Antoni Gaudi, Stuart Davis, Roy Lichtenstein, Claes Oldenburg, Vincent Van Gogh, WA Dwiggins, Frederic Goudy, Doug Johnson, Charles White III, Victor Moscoso … I fear I'm leaving too many out.

Who is or was your greatest mentor?
Jay Marino, "The Master Composer", for whom I worked as an assistant typesetter while attending graduate school. He always referred to me as "Pinocchio" and promised me that someday I would become a "real boy."

Who among your contemporaries today do you most admire?
Michael Doret, Gerard Huerta, and Louise Fili.

Who have been some of your favorite people or clients you have worked with?
Too many to mention, but I must include Stéphane Ouaknine, the scion of a historied French pharmaceutical family with roots in Morroco. I worked with Stéphane on developing the identity and packaging for La Societe Parisienne de Savons among numerous other projects and discovered a rare client who trusted himself enough to have confidence in me.

Given all you have accomplished, what is your greatest professional achievement?
I don't try and keep track of "achievements." I prefer to just be grateful for all the opportunities that I've been given.

What interests do you have outside of your work, and do those interests influence your work and career?
I must start with my daughters Anna and Molly. Their mother was the incredible designer Lorraine Louie, who burned so bright but, sadly, far too briefly. I play guitar and like music like so many illustrators I know. I am obsessed with the city of New York and intend to continue my days walking its streets and exploring its neighborhoods as long as I am capable. I am constantly observing my surroundings and being influenced by everything that catches my attention.

What professional goals do you still have for yourself?
I can't imagine even asking for more than I've already been given. I just want to continue to keep making stuff.

What advice would you have for students starting out today?
The world of design appears to be a magical playground from the outside, but if there's any other career that you are willing or capable of pursuing, do that.

Daniel Pelavin www.pelavin.com
See his Graphis Master Portfolio on graphis.com.

not peter max©

Parody Illustration, Steve Brodner's Caricature Bootcamp, SVA

Book Cover

Book Cover Illustration

FIRST CLASS

In-Flight Wines, Illustration for Wall Street Journal

Advancing Technology, Computerworld Magazine

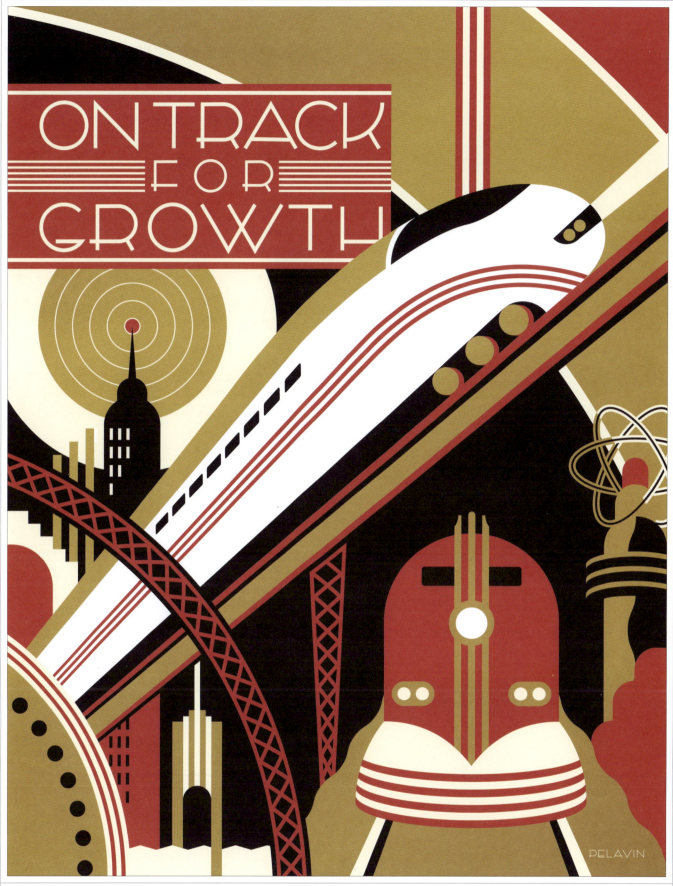

Article Opener, On Track for Growth, Strategy + Business Magazine

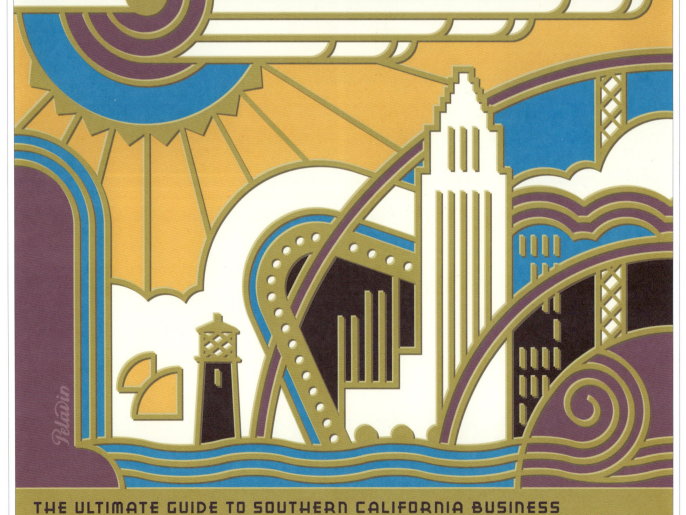

HOOVER'S GUIDE TO THE TOP SOUTHERN CALIFORNIA COMPANIES

THE ULTIMATE GUIDE TO SOUTHERN CALIFORNIA BUSINESS

Cover, Hoover's Guide to the Top Southern California Companies

1. Title Design, Emperor du Fromage, Gentlemen's Quarterly / 2. Hand Cream Packaging, La Societé Parisienne de Savons / 3. Cover, The Mexican Mafia, El Internazionale Magazine
4. Soap Packaging Design / 5. Cover Typographic Design, Variety Magazine / 6. Packaging for International Costmetics

LOS ANGELES MAGAZINE PROUDLY PRESENTS

THE DREAM FACTORY

A rare glimpse into the hidden corners of the Warner Bros.
studio back lot, where history is made every day and
even the brooms have stories to tell By Nancy Miller

A 20-PAGE PORTFOLIO By Dan Winters

PRODUCT & INDUSTRIAL DESIGN

Diamond Aircraft Industries is a Chinese-owned aircraft manufacturer located in Wiener Neustadt, Austria. Founded in 1981, they have its own facilities in Austria as well as Canada. Diamond Aircraft is known for the production of the Diamond DA42, first manufactured in 2004.

Empty Weight: 3,109 lbs.
Wingspan: 44 ft. 4 in.
Wing Area: 175.3 sq. ft.
Height: 8 ft. 2 in.
Length: 28 ft. 1 in.

Cruise Speed (TAS): 365 km/h or 176 kts.
Climb Rate: 7.9 m/s or 1,550 ft/min
Range: Up to 1,215 nm. or 2,250 km.
Engine: 168hp AUSTRO jet-fuel engine AE300
Features: Four seats, convenient access;

panoramic canopy; luxurious leather interior; LED interior lighting; baggage storage in the nose compartments and cabin
Cockpit: Garmin G1000 NXi glass cockpit
Line of Diamond Aircraft: Singles: DA20,

DA40, DA50 RG. Twins: DA62, DA42
Website: www.diamondaircraft.com/en

The DA42-VI is Diamond Aircraft's latest version of the DA42. There have been nearly 1,000 units sold worldwide. The first DA42 version was introduced in 2004, the DA42 NG in 2009, and the DA42-VI in 2011, which boasts aerodynamic improvements compared to its predecessor and reaches a maximum operating altitude of 18,000 ft. The aircraft holds up to four passengers and travels up to 365 km/h TAS. However, the DA42's flight performance remains uninhibited by both its active and passive safety, providing optimal travel for all who fly in it. The all carbon composite airframe provides safety, efficiency, and is extremely durable, even in extreme conditions. All of these

distinctive features are why the Airbus Flight Academy Europe chose to train 200 pilot cadets with this exact model.

Diamond Aircraft designed the DA42 for both the passengers and pilot. Climate controlled seats, LED interior lighting, as well as the option to customize the exterior color truly makes this plane what Diamond Aircraft describes as the definition of perfection. The DA42's distinct safety features and sleek design is marked by its Garmin G1000 NXi glass cockpit and wrap-around canopy, allowing for a panoramic view for its passengers. It's no wonder that Diamond Aircraft's latest model won the 2020 Golden A' Design Award.

AT DIAMOND AIRCRAFT WE PRIDE OURSELVES ON OUR AVIATION ENTHUSIASM AND ARE STRIVING TO BE IN A LONG-TERM LEADERSHIP POSITION IN WORLDWIDE GENERAL AVIATION…CREATING A NEW ERA OF…AIRCRAFT THAT ARE FUN TO FLY… **Bin Chen,** *Chairman*

Opposite: Ranging from $1,700 to $4,300, these mirrors are hanging works of art. Bower Studio, composed of Danny Giannella, Tammer Hijazi, and Jeffrey Renz, is a New York-based furniture and product design studio with a focus on decorative, functional mirrors. Their most memorable work is their Melt Collection. Cut with a computerized machine and mounted on wood substrate, each mirror features a long, sloping form that is draped over thick wooden dowels. Though made of rigid glass, the mirror looks loose and fluid, like it's about to flop onto the floor giving the piece a soft appearance. And with four different glass options (clear, peach, bronze, and black), you have plenty of choices to decorate your home with.

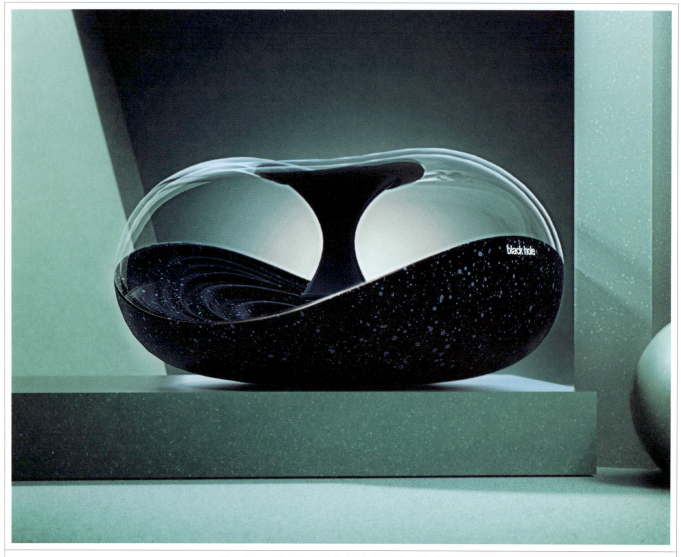

(Opposite page) Photo by Alexis Christodoulou / (Above) Black Hole

Above: While there's no word on price or availability yet, don't be surprised to find this speaker in a store near you! Designed by Arvin Maleki and Ayda Mohseni from Futuredge Design Studio (who received a 2020 Gold A'Design Award), this portable speaker mimics a black hole, a region in space where, thanks to strong gravity, nothing can escape it. The Black Hole appears fluid and weightless, a transparent layer encapsulating the operating system so the consumer can see its insides. This sense of spatial freeness is further emphasized by blue LED lights, creating the appearance of the night sky. These lights let the speaker also work as a table lamp, altering one's music listening experience. Futuredge's speaker is easy to use, connecting to any mobile device via Bluetooth, and features USB ports for external storage. Talk about being out of this world!

A

ARCHITECTURE & EXHIBITS

For $265,000, you can travel in luxury with the new Bowlus Terra Firma camper.

Bowlus

Exterior Width: 80'' ft.	**Base Weight:** 3,200 lbs.	**Black Water (Per Cassette) Capacity:** 4.5 gal.	**LP Tank:** ASME 6.7 or 28.3 LBS gal.
Exterior Length: 25'9'' ft.	**GVWR:** 4,000 lbs.	**A/C:** Comparable to 10,000 BTU	**Battery:** 8 kWh* Lithium-Iron-Phosphate Battery
Exterior Height: 8'6'' ft.	**Net Carrying Capacity:** 800 lbs	**Boiler Furnace/Water Heater:** 25,000 BTU	**Price:** Starts at $265,000
Interior Height: 6'4'' ft.	**Fresh Water Capacity:** 19 gal.	**Refrigerator:** 3.1 cu ft.	**Website:** www.bowlus.com
Hitch Weight: 300 lbs.	**Grey Water Capacity**: 21 gal.	**Sleeping Capacity:** 4 People	

The Terra Firma has overhead skylights, a Zen master bedroom, and an outdoor kitchen setup for lots of great space, along with HEPA air filters, UVC lighting, and a water filtration system that keeps everyone comfortable and healthy. It even has a special pull-out food tray for your dog. Everything is powered by a lithium-iron-phosphate battery and can be managed through touchscreen controls.

If you're concerned about safe trailering, this camper has a triple-axis motion-sensitive accelerometer that allows for responsive smooth braking and a built-in GPS to track your trip status. In addition, it can be easily towed by a Tesla X, a Porsche Macan, or BMW 7.

Created by Hawley Bowlus, an aircraft engineer known for having built Charles Lindbergh's *Spirit of St. Louis* in 1927,

Bowlus then built his first trailer in 1934 to help transport flight crews to remote takeoff locations. Since then, the company has produced the best in travel trailers.

Priced from $190,000 to $265,000, Bowlus models, with their aircraft-inspired designs, have been built to last for years, and have inspired other brands like Airstream.

From $39,500 to $161,900, Airstream has a lower price range with six different models and is still a great product. They have a huge following including celebrities like Matthew McConaughey and Ralph Lauren. (To read more about Airstream, access our Graphis Journal 357.)

To watch videos of the Bowlus, check out their YouTube channel at www.youtube.com/channel/UCnPYrcIMMm09X-ZeP7fWBnaA.

THE BOWLUS TERRA FIRMA TRAILER WRAPS YOU IN A WARM SENSE OF WELL-BEING THAT COMES WITH FEELING AT ONE WITH THE WORLD. **Leo Davie,** *The Coolector*

AERO ENGINEER HAWLEY BOWLUS FIRST BUILT THE *SPIRIT OF ST. LOUIS* FOR CHARLES LINDBERGH.

At $17,500, the Jupe pod is a great deal given the prices for Bowlus and Airstream. With Jupe pods, you can still camp in style thanks to this compact, collapsible cabin that can easily fit in the trunk of your car and be assembled in a few hours.

Photography by Michael Grimm

Created by Cameron Blizzard and Jeff Wilson and designed by a team including former employees from Tesla and Space X, this sustainable unit is adaptable to most terrain while leaving the ground and surroundings undisturbed and providing a great view with lots of privacy. At 111 square feet, the Jupe pod can fit a queen-size mattress and two end tables (which are included), and its 11 feet ceiling means you can just walk right in. The birch wood floor has hidden storage cubbies, and the front-facing facade can open up into a panoramic window.

The pod is composed of fire-resistant canvas and aluminum rods, which are embellished with LED lights for both interior and exterior lighting. If you're worried about staying connected while off the grid, solar energy and battery-powered electrical outlets and USB ports provide excellent Wifi access.

The best part about this tent is that you can take it into the woods to a great location and have a total private experience with the beauty nature can provide. It's all determined by how much you are willing to spend.

To learn more about the Jupe pod and preorder your own, visit www.jupe.com.

Look for more products of value for automobiles, planes, boats, and other new items that international design professionals are continuously innovating in our future issues.

THE JUPE POD WAS DESIGNED BY FORMER TESLA AND SPACE X EMPLOYEES AND IS ADAPTABLE TO MOST TERRAIN.

THE POD'S DESIGN MERGES UTILITY AND SURFACE BEAUTY, WITH EVERY UNIT BUILT TO WITHSTAND THE OUTDOORS WITH RESILIENCE AND ENDURE AGE.

Anmol Ahuja, *Senior Features Writer, stirworld.com*

mora

THE TIME I WORKED WITH BRAD AS A TEACHING
ASSISTANT WAS INVALUABLE. HE GOES BEYOND
THE EXPECTATIONS OF AN EDUCATOR.
I'LL FOREVER BE GRATEFUL FOR HIS GUIDANCE
AND MENTORSHIP.

Yuma Naito, *Former student and Designer*

BRAD'S SYSTEMATIC PROCESS AND THOUGHTFUL
APPROACH TO RESEARCH TAUGHT ME THAT THE
STORY BEHIND THE WORK, AND HOW YOU ARRIVE
AT THE VISUAL EXPRESSION OF AN IDEA, CAN BE
MORE IMPORTANT THAN THE FINAL OUTPUT ITSELF.

Roy Tatum, *Designer and Educator*

BRAD'S MOST MEMORABLE PROMPT DURING
CRITIQUES ALWAYS CAME AS A PAIR OF QUESTIONS:
"WHAT DO YOU SEE? WHAT DO YOU RESPOND TO?"
TO THIS DAY, THEY ARE A REMINDER TO TRUST
MYSELF AND FOLLOW MY INSTINCTS.

Paul Hoppe, *Former student and designer*

Life
in the
Deep
○
Monterey
Submarine
Canyon
○

mora

Monterey Ocean
Research Aquarium

Monterey Ocean Research Aquarium, New Talent Annual 2016. Platinum-winning student: Patrick Slack

Introduction by **Rudy Manning** *Founder and Chief Creative Officer of Pastilla*

I've known Brad Bartlett for close to twenty years. However, in the past four years, we began to work closely together while teaching at ArtCenter College of Design in the Graphic Design and Transmedia Area. One of Brad's attributes that has impressed me the most is his ability to question and explore the role of the graphic designer and to re-imagine the possibilities of what graphic design can be. That ability allows him to make connections in other fields such as technology, film, language, and sound. Brad gets influenced by these disciplines and brings them into his design practice to create something new. That thinking and vision has pushed his work to stand out, and he's carved out a unique space in the design field. He takes that mindset and encourages his students to embark on a journey that inspires new perspectives and views on design. I don't say this often, but he's genuinely one of the best designers I've met in my twenty-year career. And I still get inspired by his forward-thinking perspective on design and where it's going.

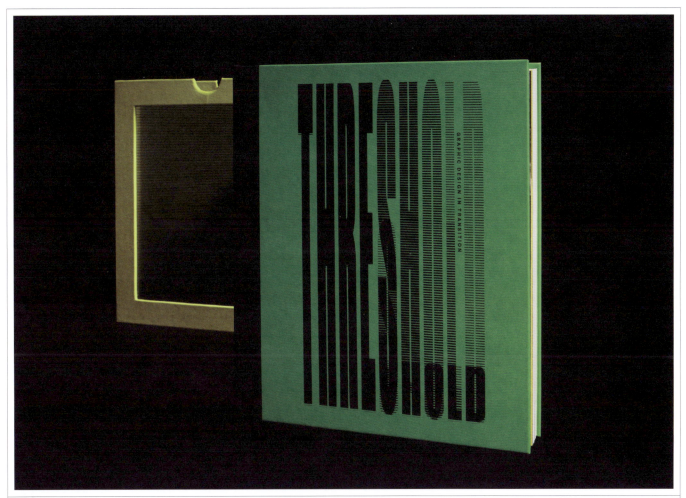

Threshold, New Talent Annual 2021. Gold-winning student: Shiang-jye Yang

MEANING IS NOT FOUND IN THE OBJECTS WE CREATE OR THE ARTIFACTS WE DESIGN, BUT IN THE RELATIONSHIPS WE SHARE WITH EACH OTHER AS HUMANS. **Brad Bartlett,** *Professor and Director, ArtCenter College of Design*

THE CELEBRATION OF HUMAN'S GREATEST INVENTION

FROM WHEELS TO REELS

WELCOME, FREE ENTRY BikeFilmFest BICYCLE FILM FESTIVAL.COM

Bicycle Film Festival Identity, New Talent Annual 2020. Gold-winning student: Jianzhen Joe Qiao

What is your process for selecting a student for your class?
My highest intent is to create the best possible conditions for a student to be successful in our classroom. Although there isn't a formal process for selecting students, I make sure to meet with each one prior to the enrollment process. This informal conversation is important, as it not only gives me a sense of skills and competencies, but insight into deeper motivations. I want to know their story. I want to know who they are, where they come from, and how they interpret the world.

What are the qualifications you require?
Our students take foundational courses taught by our best instructors. Those courses are prerequisites for the upper term classes I teach. I'm also the director of transmedia in the graphic design program. In our area, we design curriculum in a modular way that can be uniquely configured for each student. Additionally, I offer advisement to pin point courses and instructors that meet the specific needs and interests of a student.

What are the disqualifications?
In the past, I've had thirty or forty students on the internal waitlist, but unfortunately I can only take twelve, so no disqualifications, but certainly limits. The classes are largely self-selective and students only pursue them when they feel confident and ready.

What might be a typical first assignment?
I start each class with a design charrette. The brief asks students to design a response to the following provocation: Design is a reflection of Culture / Culture is a reflection of Design. This short, intense exercise encourages students to examine the dynamic relationship a designer shares with a world shaped by design. Designers are instrumental in shaping culture while simultaneously being shaped by culture.

Can you talk about process and research?
Research should always guide the work. The outward expression of an idea should be based on the internal parameters of a project. Those parameters should be driven by research, from reading and writing, to drawing and mapping, to prototyping and experimenting, to creating unique tools or dynamic systems.

Students learn through making. I encourage them to embrace this process and to collect, organize, and interpret their research through the language of graphic design. I challenge them to look for underlying patterns and unexpected connections and to synthesize their findings into a compelling visual narrative.

Are real clients suggested?
In most cases, students aren't working directly with outside clients, but proposing a subject matter or institution in order to create a compelling narrative or dynamic visual identity. We want the projects to be deeply researched and well-executed. To achieve this, it's more practical for students to work with real content sourced from actual institutions. During our midterm and final presentations, we invite outside designers, educators, and alumni to participate in critique.

Might you also ask students to choose a passion of theirs for the assignment?
Yes; when you're entrusted to make a choice, you feel empowered. Yet, in letting students choose, we set guide rails so that the decision fits within the project brief.

I also believe the process of design can be transformative. This is especially true when passion fuels the engine that drives the project forward. This operates on many different levels. At the level of society, design can be a catalyst for social change. At the level of the individual, it can also be a deeply personal investigation into the creative process. This process of discovery nourishes the creative soul while satisfying the desire to learn something new. In the end, the process is far more valuable than the end result.

Do you work with students individually? Or...
I was fortunate to lead a studio in Berlin that was co-taught by futurist and science fiction writer Bruce Sterling, along with my colleague Rudy Manning. The theme was post-humanism and the students were divided into three teams focused on the subtopics of artificial intelligence, genetics, and robotics. Berlin is the nerve center for art and design in Europe and was the perfect backdrop for conducting research. In the process of collaboration, individuals who subjugate their egos for the greater good of the project seem to adjust well to the unique challenges that arise. Something magical happens when the pieces come together and the whole is greater than the sum of the parts.

Yet, even when the pieces don't fit and students struggle, learning still happens. I tell my students that a curved line is a lot more interesting than a straight line. The same holds true for many things. Struggle creates empathy and grit. It keeps us off-balance and opens us up to something new.

Do you present their work so that you and the rest of the class can participate in criticism?
Students share their progress every class session. It's a way to keep pace while providing an opportunity for students to strengthen their verbal communication skills. I encourage students to talk about their process so that we can enter into the work and be part of the journey.

There are many ways to lead a class, and I've found it's better to be an orchestra conductor than a drill sergeant. When you create space for each voice to be heard, the students feel open to exchange ideas. That supportive environment creates a sense of community. I tell my students honest feedback is an act of generosity and that critique is an opportunity for growth, both as designer and as a person. In the end, the collective mind is far more insightful than the opinions of a single individual.

How do you develop and raise your student's visual and verbal standards?
In addition to critique, I ask my students about their frame of reference. I ask them where do they find inspiration. Are they consuming content on Instagram, endlessly scrolling through design feeds? Are they reading about design in the library, leafing through history books? Are they inspired by photogra-

Zanele Muholi Poster, New Talent Annual 2019. Platinum-winning student: Charles Lin

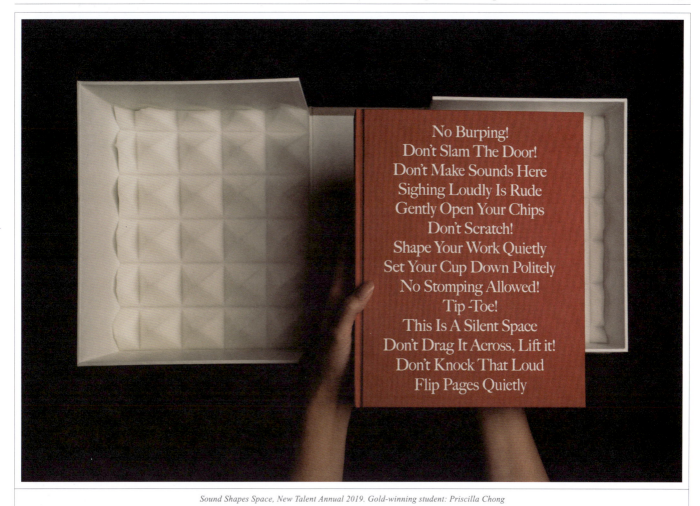

No Burping!
Don't Slam The Door!
Don't Make Sounds Here
Sighing Loudly Is Rude
Gently Open Your Chips
Don't Scratch!
Shape Your Work Quietly
Set Your Cup Down Politely
No Stomping Allowed!
Tip-Toe!
This Is A Silent Space
Don't Drag It Across, Lift it!
Don't Knock That Loud
Flip Pages Quietly

Sound Shapes Space, New Talent Annual 2019. Gold-winning student: Priscilla Chong

phy or film or fashion or writing or other creative disciplines adjacent to graphic design? I ask them how these references influence what they make and how they judge their work. I want them to develop a level of critical self-reflection.

With the semester's end, what kind of advice
do you give to the class?
Several years ago I was honored with ArtCenter's prestigious great teacher award and had the opportunity to speak before the graduating class. Here's the advice I shared with them:
• Meaning is not found in the objects we create or the artifacts we design, but in the relationships we share with each other as humans.
• A career is not something out there that you find. It's not hidden under a rock in the sculpture garden. It's not pinned to a bulletin board on Hillside Campus. It's not posted on a website somewhere. It's something you actively construct over time.
• Your intellectual curiosity is contagious. Spread it widely. It's the antidote to conformity and groupthink.
• Work ethic is always more valuable than talent. What is talent? You can't measure talent. You can't define talent. You can't teach talent. Work ethic is something you can control. Your diligence and determination will always pay off in the end.
• The creative process is iterative. Always explore many, many possibilities. The poet Allen Ginsberg once said, "First thought, best thought." I believe he was wrong. Next thought, best thought.
• Method is more important than style. Your methodical approach to solving problems will sustain you for the rest of your career. Style is fast and dies young.
• Critique is always an opportunity to grow, both as an artist and as a person. Be generous in the feedback you give to others, and be open to the feedback that you receive.
• Your energy is finite. Be strategic and methodical in your dispersal of it.
• We all aspire to create change and to make the world a better place, but that can seem like a daunting task – an insurmountable challenge. Simply start small. Then make better. Then inspire others to make better. Small steps towards a larger goal. And that larger goal is to create real change.

Can you name a few of your past students
who have gained success?
I've been lucky to have been part of the educational experience of so many great students, and so it's difficult to list only a few. Paul Hoppe is an associate creative director at 2x4 and was my teaching assistant at ArtCenter many years ago. Daniel Young was also my teaching assistant and now he leads a team at Google. Ben Schwartz was a Walker Art Center Fellow and is a gifted writer and book designer whose work I collect. Yuma Naito leads a team at Apple and was one of our most celebrated recent graduates. Lastly, Roy Tatum was my teaching assistant and also our valedictorian. He's worked at IDEO and Nike and now teaches with me at ArtCenter.

Brad Bartlett www.artcenter.edu
See his Graphis Master Portfolio on graphis.com.

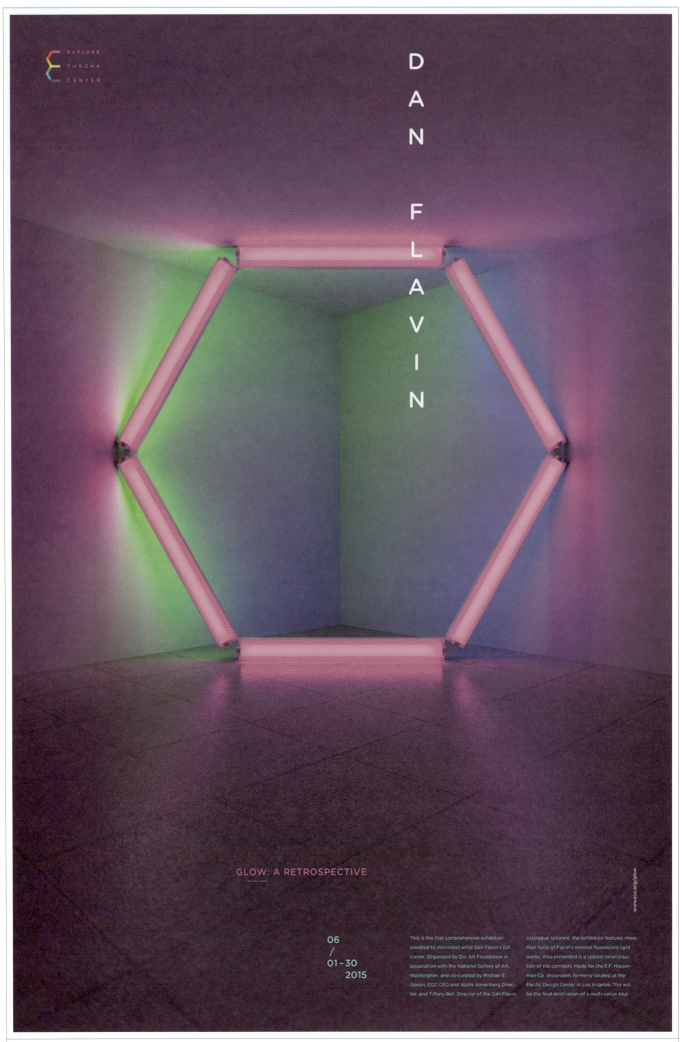

EXPLORE
CHROMA
CENTER

DAN FLAVIN

GLOW: A RETROSPECTIVE

06
/
01–30
2015

This is the first comprehensive exhibition devoted to minimalist artist Dan Flavin's full career. Organized by Dia Art Foundation in association with the National Gallery of Art, Washington, and co-curated by Michael E. Govan, ECC CEO and Wallis Annenberg Director, and Tiffany Bell, Director of the Dan Flavin catalogue raisonné, the exhibition features more than forty of Flavin's seminal fluorescent light works. Also presented is a special reconstruction of the corridors made for the E.F. Hauserman Co. showroom, formerly located at the Pacific Design Center in Los Angeles. This will be the final destination of a multi-venue tour.

www.ECC.org/glow

Chroma Center - Glow: A Retrospective, New Talent Annual 2016. Platinum-winning student: Cynthia Lou

Spector Press
Markus Dreßen, Anne König,
Jan Wenzel, Harkortstraße 10,
D-04107 Leipzig
Germany

+49.341.264 510 12
www.spectorbooks.com

SPECT⊙R

Spector's publishing practice is settled squarely in
the intersection of art, theory, and design. Based
in Leipzig Germany, our publishing house explores the
possibilities offered by an active exchange between
all parties involved in the book production process:
artists, authors, book designers, lithographers,
printers and bookbinders.

Spector Press, New Talent Annual 2020. Gold-winning student: Yura Park

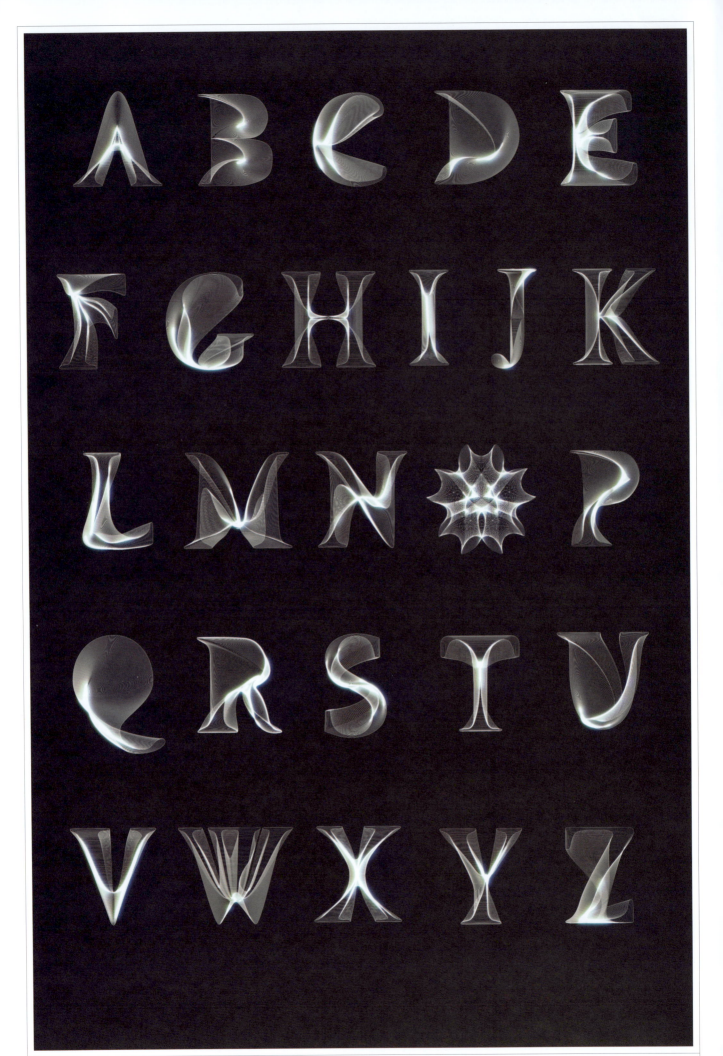

Manifold Reality, New Talent Annual 2016. Gold-winning student: Jay Kim

Graphis Books

POSTER

DESIGN

ADVERTISING

PHOTOGRAPHY

NUDES

TYPOGRAPHY

PROTEST POSTERS

New Talent Annual 2021

GraphisNewTalentAnnual2021

This was a great collection of talent and creativity, resulting from extraordinary out of the box thinking.

Carmit Haller, Designer & CEO Carmit Design Studio

2021
Hardcover: 272 pages
200-plus color illustrations
Trim: 8.5 x 11.75"
ISBN: 978-1-931241-99-1
US $90

This Annual presents work from award-winning instructors and students. **Platinum: Advertising:** Alexi Beltrone, Jay Marsen, Kevin O'Neill, Taylor Shipton, David Stadttmüller, and Mel White. **Design:** Justin Abadilla, Brent Barson, Rob Clayton, Justin Colt, Jeff Davis, Ann Field, Bill Galyean, Seung-Min Han, Miguel LeeDong-Joo Park, Hank Richardson, Paul Rogers, Renee Seward, Tracey Shiffman, Taylor Shipton, Doug Thomas, and David Tillinghast. This year we awarded **20 Platinum, 147 Gold,** and **398 Silver** award-winning work from students whose professors drove them to create highly-professional work. We award **498 Honorable Mentions** as well and encourage new talent to submit. All winners are equally presented and archived on our website. This book is a tool for teachers to improve their students' work and see where their school stands internationally.

Advertising Annual 2021

GraphisAdvertisingAnnual2021

As advertising continues to evolve, the Graphis competitions will continue to present exceptionally creative work.

Tony Wu, Executive Creative Director, BBDO/JI

2020
Hardcover: 224 pages
200-plus color illustrations
Trim: 8.5 x 11.75"
ISBN: 978-1-931241-95-3
US $90

Awards: This year, Graphis awarded a total of 173 awards. 9 Platinum, 71 Gold, 93 Silver, and 11 Honorable Mentions are presented in this book. **Platinum Winners:** 72andSunny Los Angeles, ARSONAL, The Beacon (Kohler Co), Colin Corcoran, The Designory Inc., FOX Entertainment, INNOCEAN USA, Judd Brand Media, and Young & Laramore. **Judges:** All entries were judged by a panel of past award winners from our Graphis Annuals. They include, from Ecuador: David Chandi; and from the USA: Silver Cuellar, Michael Raso, and Tony Wu. **Content:** Platinum and Gold winners relate their assignments and how they arrived at their award-winning results. This Annual is an important tool and a valuable resource of information for creative professionals, professors, students, and anyone with an interest in the visual arts.

Design Annual 2021

GraphisDesignAnnual2021

PLATINUM WINNERS:
Carmit Design Studio
Eduardo del Fraile Studio
Fuzhou BY-ENJOY
 Brand Design Co., Ltd.
Journey Group
Leo Lin Design
Michael Pantuso Design
Randy Clark
Ron Taft Design
Shadia Design
Subplot Design Inc.
Tsushima Design
Young & Laramore

2020
Hardcover: 272 pages
200-plus color illustrations
Trim: 8.5 x 11.75"
ISBN: 978-1-931241-94-6
US $90

Awards: This Annual awards 12 Platinum, 125 Gold, 317 Silver awards, and 241 Honorable Mentions for outstanding achievement in design. **Platinum Winners:** Randy Clark, Eduardo del Fraile, Carmit Makler Haller, Young Huale, Journey Group, Leo Lin, Shadia Ohanessian, Michael Pantuso, Subplot Design, Ron Taft, Hajime Tsushima, and Young & Laramore. **Judges:** All work was judged by a panel of past Platinum and Gold winners: John Fairley, Gavin Hurrell, Erin Mutlu, Alvaro Perez, Diogo Gama Rocha, Jared Welle, and Yin Zhongjun. **Content:** Award-winning work from the judges, and full-page presentations of Platinum and Gold-winning design work. Silver and Honorable Mentions are also presented, and a list of international design museums is included.

Poster Annual 2021

GraphisPosterAnnual2021

PLATINUM WINNERS:
Ariane Spanier Design
Fons Hickmann m23
Fuzhou BY-ENJOY Brand
 Design Co., Ltd.
Hoon-Dong Chung
FX Networks/Icon Arts
 Creative/Arsonal
Landor
Marcos Minini Design
OGAWAYOUHEI DESIGN
Tsushima Design
Underline Studio

2020
Hardcover: 240 pages
200-plus color illustrations
Trim: 8.5 x 11.75"
ISBN: 978-1-931241-91-5
US $90

Awards: This year Graphis awarded 10 Platinum, 94 Gold, 220 Silver awards, and 171 Honorable Mentions for exemplary talent in poster design. **Platinum Winners:** Hoon-Dong Chung, FX Networks, Fons Hickmann, Young Huale, Landor, Marcos Minini, OGAWAYOUHEI Design, Ariane Spanier, Hajime Tsushima, and Underline Studio. **Judges:** All work was judged by a panel of past Platinum and Gold winners: Mann Lao (Chiii Design), Pekka Loiri, Jisuke Matsuda (Atelier Jisuke), Marcos Minini, Spencer Till (Lewis Communications), and Thomas Wilder (Collins). **Content:** Award-winning work from the judges, and full pages of Platinum and Gold-winning posters. Silver and Honorable Mentions are presented, and a list of international poster museums is included.

Photography Annual 2020

2020
Hardcover: 256 pages
200-plus color illustrations
Trim: 8.5 x 11.75"
ISBN: 978-1-931241-85-4
US $90

Awards: Graphis presents 12 Platinum, 94 Gold, 117 Silver Awards, and 65 Honorable Mentions in this annual.
Platinum Winners: Craig Cutler, Bruce DeBoer, Nicholas Duers, Nick Hall, Vincent Junier, Jonathan Knowles, McCandliss and Campbell, Lennette Newell, Joseph Saraceno, Howard Schatz, Michael Schoenfeld, and Sarah Ward.
Judges: Work was judged by a panel of photographers who had been past winners, such as Graphis Masters Athena Azevedo, Andreas Franke, and Ricardo de Vicq de Cumptich, as well as Colin Faulkner and Frank P. Wartenberg.
Content: Photos from judges and award-winning photographers. Also included is a retrospective on the past decade of winning photography, and a list of international photography museums.

Nudes 5

N U D E S 5

2019
Hardcover: 256 pages
200-plus color illustrations
Trim: 10.06 x 13.41"
ISBN: 978-1-931241-84-7
US $90

The fifth volume in this series, Nudes 5 continues to present some of the most refined and creative nudes photography. Just as this genre helped elevate photography into a realm of fine art, one will find that many of the images on these pages deserve to be presented in museums. Award-winning photographers include Erik Almas, Rosanne Olson, Klaus Kampert, Howard Schatz, Phil Marco, Joel-Peter Witkin, and Chris Budgeon, among others.

Books are available at www.graphis.com/store

Designer: **Mark Hess** | Client: **Self-initiated**

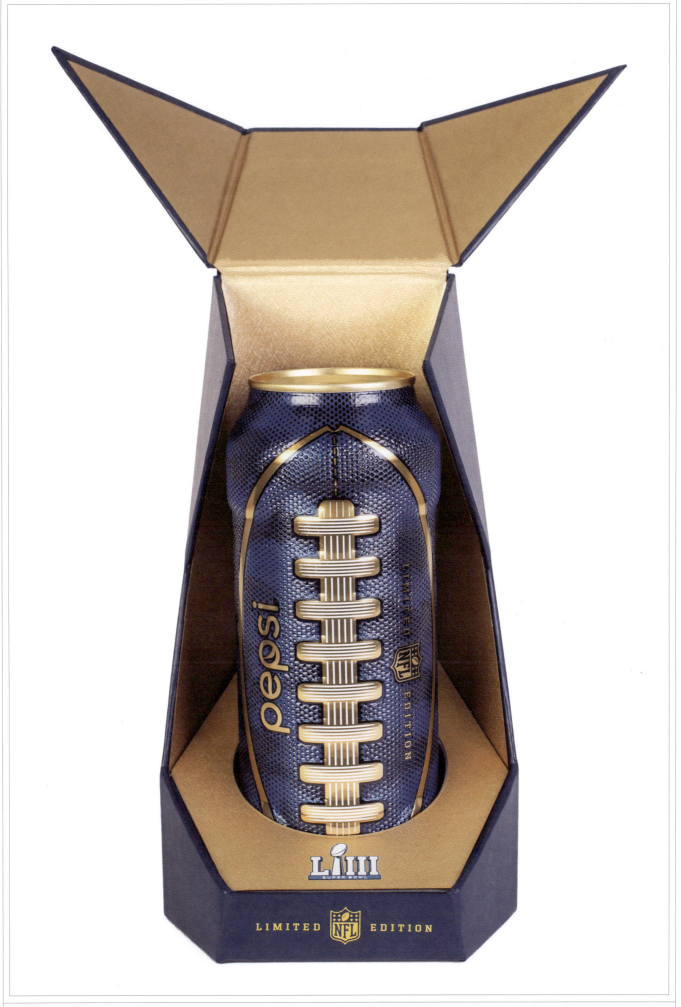

Design Firm: PepsiCo Design & Innovation | Client: Self-initiated

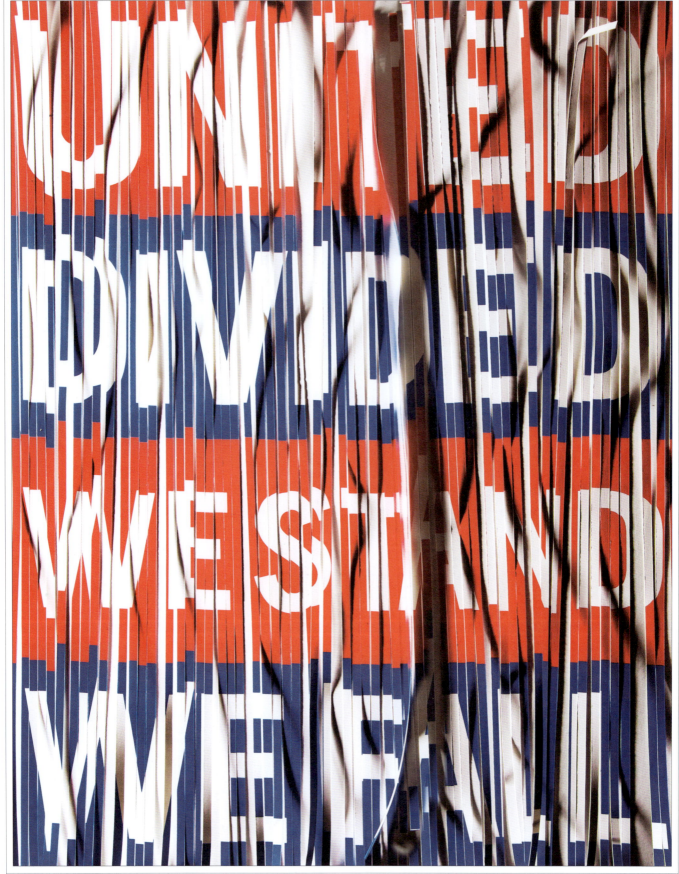

Design Firm: IF Studio | **Client: Self-initiated** | **Designers: Toshiaki Ide, Hisa Ide, John Balbarin**

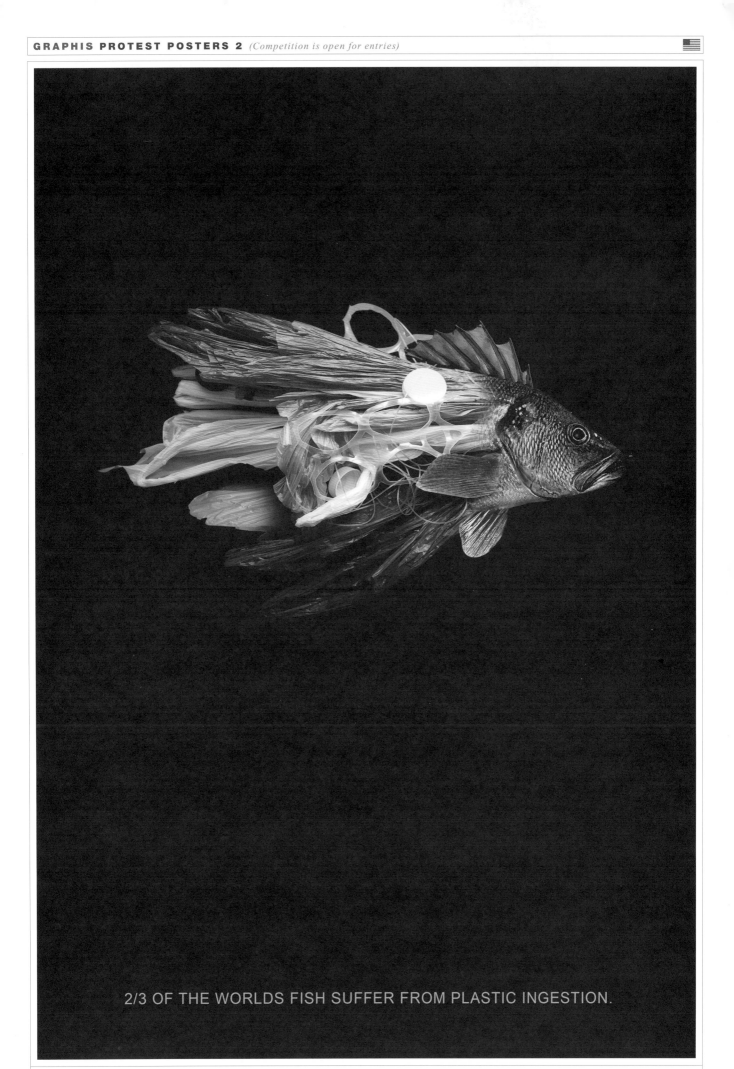

2/3 OF THE WORLDS FISH SUFFER FROM PLASTIC INGESTION.

Designer: Scott Laserow I **Client: Segunda Llamada**

Quinnton Harris

Publicis Sapient Group creative director, Experience and co-leader of Global Computational Design, focusing on improving our design operation systems. He plays a critical role in accelerating CXO John Maeda's vision for fostering a more inclusive, multidimensional, and cohesive Experience capability. He also serves as head of Experience for San Francisco. He also completed a short tenure as John Maeda's chief of staff, finding much success in pushing critical CXO initiatives, implementing systems for global collaboration, and enhancing internal communication strategies. Harris recently led the #hellajuneteenth movement and got over 600 companies committed to observing Juneteenth as a paid holiday for its employees. Prior to joining Publicis Sapient, Quinnton was the inaugural creative director at Blavity, Inc., and before that led design at Walker & Company Brands, a start-up consumer products and tech company notably acquired by Procter & Gamble. He is an MIT alum, graduating with a SB in mechanical engineering and dual minors in architecture and visual arts.

Patti Judd

Award-winning creative director, accomplished marketing and film executive, and co-founder of the San Diego International Film Festival, Patti recently joined Graphis as chief visionary officer. A key initiative was forming the Graphis Industry Advisory Board to promote greater industry insights and connections globally. Patti blends business savvy gained from 20+ years at her agency with the entertainment biz acumen garnered from working in music and film. Her studio, Judd Brand Media, champions her passion for creating innovative work, receiving over 100 awards in design, advertising, and marketing. Her work includes notable global brands such as WME, Disney, Mattel, Montreux Jazz Festival, Century 21, Aramark, Service America, and Hilton, alongside numerous emerging brands, recording artists, and filmmakers. Her influence goes from helping launch a major live music venue, where she was a key player in its growth to one of the top live jazz venues in the world, to co-founding the San Diego International Film Festival. She holds two executive producer credits for a children's TV series on Nickelodeon and a feature film in association with the BBC, which premiered at Sundance (acquired by Universal Pictures). Currently, she is in development as executive producer on an exciting new animated children's series. Patti's nonprofit work includes being a foster youth board member and a past president of an arts and culture board benefiting Balboa Park, the largest urban cultural park in the US. Recently, she was awarded as an Altruist Honoree by Modern Luxury Magazine.

Duncan Milner

Born in Kingston, Jamaica, Duncan was drawn to the world of advertising, intrigued by the clash of art and commerce. This led to art school in Toronto and the launch of his career at small, but creatively respected shops in San Diego, where his good work caught the eye of Chiat/Day. Various roles in the Chiat/Day network included stints in the Toronto, St. Louis, and New York offices on blue-chip brands like Nissan, Pepsi, Mars, and Levi's. This led to Duncan being handpicked to co-found TBWA/Media Arts Lab, where, as chief creative officer, Duncan worked closely with Steve Jobs to help re-build the Apple brand, launching the iPod, iPhone, iPad, Apple Watch, and Apple TV. Duncan's work has been recognized at numerous awards shows, including the iconic "Mac vs. PC" campaign, which was named Campaign of the Decade by Adweek, won the 2013 Cannes Press Grand Prix, and earned the 2014 Emmy Award for Best Commercial, and Apple's "Shot on iPhone 6" campaign, which won the 2015 Cannes Grand Prix and Grand Clio for Outdoor. In 2015, he was named to Fast Company's Creative 50. In 2017, TBWA\Media Arts Lab and Apple were awarded the One Show's Penta pencil, recognizing the successful partnership and outstanding body of work between agency and client over five years. Currently, Duncan consults with numerous brands and has also taken on a new role sharing his experience and the occasional funny story speaking at corporate events.

Michael Pantuso

As a multi-disciplined graphic designer and artist, Michael Pantuso thrives at the intersection of creative thinking, artistic expression, and strategically inspired ideas. Throughout his career, Michael has managed his own design practice, partnered with the branding agency IDEAS360°, and held positions inside TBWA Worldhealth (formerly CAHG) and Discover Financial. Located in the Chicago area, Michael is focused on creating design and art for clients, collectors, and organizations that make a social impact—these include charities, not-for-profits, NGOs, educational and arts bodies, social enterprises, and for-profit businesses who want to do more good. Michael's practice creates all the usual outputs of a branding agency—design identities, advertising, social media, print literature, websites, email, e-newsletters, photography, etc. But he does so in the context of a bigger picture—a vision for what the brand is, and, more importantly, what it can become. It's a passion that comes from a desire to make things better. Michael's art is an extension of this passion, but it's revealed and expressed in a more visceral way. One example of this can be seen through his "Mechanical Integration" work, where he explores nature and humanity through a series of fine art illustrations that integrate natural life forms with the inner workings of mechanical components. Part of this collection was recently celebrated as a solo exhibition which began in Paris, France, followed by a tour of Europe that concluded in early 2020. Much of that work now remains in galleries and private collections.

BVK accelerates growth in life-changing categories by solving business, brand, and marketing problems with art, science, and humanity. It starts with a belief that improving lives makes for a better world. And by solving scary problems with brave ideas, we create meaningful change—for both our clients and their customers. We don't answer to shareholders, holding companies, or anyone else that gets in the way of our independence. From travel and tourism, healthcare and higher education to B2B, CPG, and non-profits—our work inspires people to improve their lives in big ways and small.

Introduction by Steve Lyons

Steve has been with the Maine Office of Tourism for more than twenty years, being named director in July 2017. He is responsible for overall operations of the Maine Office of Tourism, having moved into this position following nine years as director of marketing. In that capacity, he played a critical role in developing a tourism marketing strategy for the state of Maine. Steve was recently elected to the board of directors for the U.S. Travel Association, the national non-profit organization that represents the travel industry. He also serves on the board of directors for Discover New England, a regional international marketing collaborative.

Restless, driven, and always pushing himself toward new means of technical and aesthetic expression, Erik has made a name for himself creating award-winning imagery for esteemed clients such as the Hyatt Hotels & Resorts, Intercontinental Hotel Group, Microsoft, Absolut Vodka, Union Pacific, the Ritz-Carlton, Toyota, USPS, and America Airlines. Having been introduced to digital technologies in the latter part of his academic career, Almas quickly discovered that with these tools he could bring the qualities of film and characteristics of the darkroom to his images. By embracing Photoshop, as a painter does a brush, he has evolved, using it as an extension of his style. This embrace ensures that every client continues to receive bespoke images that are a true representation of a photographic vision—a vision always steeped in down-to-earth sensibilities, influenced by his Norwegian childhood and fed by a love of world travel. In addition to commercial assignments, Erik brings his artistic sensibilities into creative collaborations for fashion, travel, and fine art. His images, often contextualizing people or products, exist in timeless, hyper realistic twilight panoramas, engaging the viewer's imagination and sense of wonder.

Introduction by Jim Erickson

Jim Erickson lives in northern California, where he enjoys surfing and creating pictures that tell a story. He has created a stock photography company, Erickson Stock, which is unique in that the still photographs and video content it produces is character driven, a concept exclusive to Erickson Stock. Jim continues to work on projects and assignment work. He is currently working on a fine art series that shows a mature artist tackling the mystery of "The Mask" that can be viewed at unseenmenace.com. Erik apprenticed with Jim for several years, and Jim applauds Erik's success.

Colin Faulkner has the good fortune of working in a field he loves. His mother, an art teacher, started nurturing his imagination and passion with projects in his early years in Canada and Thailand that eventually led to studying sculpture at art school, and finally photography. After assisting some of Canada's top photographers, his commercial career transitioned gracefully from one specialty to another, including fashion, corporate-conceptual, food, cosmetics, furniture, and interiors, capturing the sculptural elements of each, and garnering awards and industry recognition along the way. He is relentless in his drive to bring the best to every project and loves collaborating with creative people in some of the most beautiful locations (or studios!) in the world.

Introduction by Diti Katona

Diti Katona is a co-founding partner and chief creative officer of Concrete. She is best known for her elegant and evocative work for the firm's clients in beauty, fashion, retail, and luxury goods. Having started her career working in Budapest, Diti has always sought inspiration through cultural intelligence. Well-travelled, curious, and restless, Diti has a native sense of the connections between high art, fashion, and popular culture. Chronically dissatisfied, she is constantly pushing Concrete's creative teams, turning seemingly contradictory viewpoints into surprising creative solutions. Over the years, Diti's creative work has received numerous awards from juries throughout North America, Europe, and Asia, including two lifetime achievement awards. Diti frequently lectures on design topics, serves as a faculty advisor at design schools, and judges international competitions in her field.

(Opposite page) JNSQ is a "California wine with a French twist". The images were inspired by the same mix of California Coll and French sophistication. Photographer: Erik Almas

Contents

(Opposite page) Don Julio Tequila, part of a series of four images depicting pivotal moments of Don Julio's life. Photographer: Erik Almas

Letter from the Publisher

MW01485216

Publisher and Creative Director:
B. Martin Pedersen

Chief Visionary Officer:
Patti Judd

Design Director:
Hee Ra Kim

Designers:
B. Martin Pedersen
Hee Ra Kim
Hiewon Sohn

Associate Editor:
Colleen Boyd

Editorial Intern:
Isabel Meyers

Japanese Advisors:
USA: Toshiaki & Kumiko Ide
Japan: Taku Satoh
Sakura Nomiyama

Chief Executive Officer:
B. Martin Pedersen

Cover Image:
Airplane for
Danish Air Transport.
Designed by Finn Nygaard

Published by:
Graphis Inc.
389 5th Ave., Suite 1105
New York, NY 10016
Phone: 212-532-9387
www.graphis.com
help@graphis.com

Distributed by:
National Book Networks, Inc.
15200 NBN Way
Blue Ridge Summit, PA 17214
Phone: 800-462-6420
customercare@nbnbooks.com

ISBN 13: 978-1-931241-96-0

Are you inspired?

This is the most important requirement for anyone in their chosen craft.
If you're not inspired, your fate in the future will then be having to go to work for a living.

But if you *are* inspired and love what you do, and enjoying your craft, you're not working.
Milton Glaser designed till the very day he peacefully passed away in his hospital bed.

Finn Nygaard loved and was inspired by jazz music in his early years.
This led him to become a graphic designer and fine artist to express this lifelong passion.

Talents below who will inspire *you*:

Design:
Finn Nygaard (DK), Graphis Master and AGI member who has created over 600 posters
during his career and has lectured and hosted design workshops internationally.

Atsushi Ishiguro (JP) of OUWN Co., Ltd., who lets his passion and love for food and cooking
influence his food packaging and branding design.

FBC Design (USA) of Fox Entertainment, a highly talented group of designers with dynamic
ideas whose work with movie and TV posters has earned numerous awards.

Advertising:
BVK (USA), rated by Adbrands as amongst the top 25 independent ad firms in the USA,
who promote distinctive brands and events such as the Footstock water ski championship.

Photography:
Erik Almas (USA), Graphis Master who seeks inspiration from poetry and artists like Henri
Rousseau, and built a successful career shooting fine art photographs.

Colin Faulkner (CAN), another Graphis Master who makes art out of fashion by shooting
carefully composed, award-winning still lifes that arrest viewers' attention.

Art/Illustration:
Danny Pelavin (USA), Graphis Master and type-passionate designer who developed a vintage
style that captured the attention of designers and art directors nationwide.

Education:
Brad Bartlett (USA), Graphis Master, director, and professor at ArtCenter College of Design,
who drives his students to conceive great ideas, resulting in professional level work.

Products:
The **Diamond Aircraft DA42-VI** (AT) and **Black Hole Music Speaker** (TR), both
prestigious Golden A'Design winners, and unusual **Melt Mirrors** by Bower Studios (USA).

Architecture:
The **Terra Firma Travel Trailer** by Bowlus (USA), and the **Jupe Pod**, a prefab shelter
that's portable and ready to assemble by Jupe (USA).

B. Martin Pedersen
Publisher & Creative Director